BOUND FOR SUCCESS

Bound for Success

Designer Bookbinders International Competition 2009

EDITED BY JEANETTE KOCH

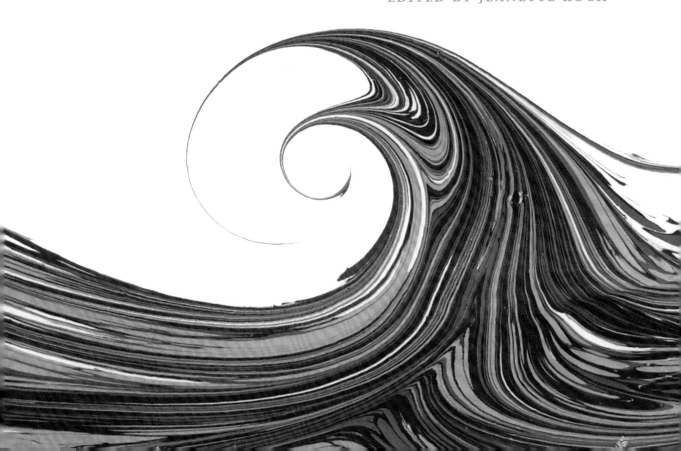

First published in 2009 by the Bodleian Library
Broad Street, Oxford OX1 3BG

ISBN 978 1 85124 352 5

This edition © Bodleian Library, University of Oxford, 2009

Cover design chosen in memory of Ann Muir, creative marbler (1939–2008).
Marbled wave © Ann Muir. One of the six hundred different marbled waves
created by her for each copy of the set book.
Photography: Sussie Ahlburg
Images © Designer Bookbinders

The set book *Water* was published by Incline Press,
36 Bow Street, Oldham OL1 1SJ.

Designed and typeset in Monotype Joanna by illuminati,
Grosmont, www.illuminatibooks.co.uk
Printed and bound by BAS Fine Art Printers,
Amesbury, Wiltshire SP4 7RT

British Library Catalogue in Publishing Data
A CIP record of this publication is available from the British Library

EXHIBITION DATES

USA TOUR

BOSTON PUBLIC LIBRARY 18 September–13 December 2009

Founded in 1848 by an act of the Great and General Court of Massachusetts, the Boston Public Library was the first large, free municipal library in the United States. The Boston Public Library's first building of its own was a former schoolhouse on Mason Street, which was opened to the public on 20 March 1854 with a collection of 16,000 volumes. In December of the same year, the Library's commissioners were authorised to locate a new building upon a lot on Boylston Street. The present Copley Square location has been home to the Library since 1895, when American architect Charles Follen McKim completed his 'palace for the people'.

In 1972 the Library expanded its Copley Square location with the opening of an addition designed by Philip Johnson. Today, the McKim Building houses the BPL's vast research collection and the Johnson Building holds the circulating collection of the general library and serves as headquarters for the Boston Public Library's twenty-six branch libraries.

In addition to its 6.1 million books, the Library boasts over 1.2 million rare books and manuscripts, a wealth of maps, musical scores and prints. Among its large collections, the BPL holds copies of William Shakespeare's First Folio as well as many of the first-edition quartos; original music scores, from Mozart to Prokofiev's *Peter and the Wolf*; and the personal library of John Adams. The Library has an active exhibition schedule drawing from these unique resources. In addition, the Boston Public Library is one of only two public libraries with membership of the prestigious Association of Research Libraries.

More than 2.2 million patrons visit the BPL each year, many in pursuit of research material, others looking for an afternoon's reading, still others for the magnificent and unique art and architecture.

Bonhams & Butterfields' San Francisco gallery is one of the largest auction salesrooms on the West Coast. Located in the celebrated Design District south of Market Street, the gallery is in easy walking distance of other bibliophilic landmarks such as the San Francisco Center for the Book and the San Francisco Public Library. The gallery was in recent years host to the West Coast celebration of the 400th anniversary of the Bodleian Library and the 150th anniversary of the Bancroft Library at the University of California.

Bonhams & Butterfields brings together two venerable firms. Founded in 1865 by a gold-rush pioneer, Butterfields is the oldest auction house in continuous operation west of the Mississippi; Bonhams was founded in Covent Garden in 1793. In 2002 Bonhams acquired Butterfields and has now expanded into dramatic new salesrooms in New York at 57th Street and Madison Avenue. With salerooms in the key markets of New York, San Francisco, Los Angeles, Sydney, Hong Kong, Dubai and London, the Bonhams group is today the fastest growing auction house in the world.

Bonhams 1793
AUCTIONEERS & APPRAISERS

On 24 January 1884, nine business and cultural leaders of New York City, all collectors of books and prints, gathered to organise a club for the encouragement of 'literary study and the arts of the book'. Their group was named after Jean Grolier (1489/90–1565), leading bibliophile of the Renaissance, patron of scholars and printers, and a royal treasurer under four French kings. In the 125 years since its founding, the Grolier Club of New York has become a mainstay of American book collecting, giving structure and direction to a movement which values books not only as vessels of knowledge, but also as physical objects. As an organisation for bibliophiles, the Grolier Club has been remarkably successful in its mission to nurture an enthusiasm for the book and graphic arts, and to offer its membership and the general public the discoveries and treasures brought to light by the serious pastimes of collecting, studying and making books.

Club members, over 3,000 of them since 1884, have pursued this mission through an impressive 125-year series of public exhibitions, a parallel record of worthy books about books beautifully produced, and the cultivation of a world-class library of 100,000 volumes on the history of books and printing, open by appointment to the entire community of scholars and bibliophiles. In attempting to share with a wider audience what our members know and love about the book and graphic arts, the Grolier Club follows a motto which Jean Grolier caused to be stamped on many of his books: *Io. Grolierii et amicorum*, which the Club has always chosen to translate as 'For Jean Grolier and His Friends'.

Contents

DESIGNER BOOKBINDERS

Designer Bookbinders is one of the foremost bookbinding societies in the world. Since its inception it has been the model for many bookbinding societies in other countries, and its fellows have an international reputation for their progressive influence on the art, design and technique of the hand-bound book.

The Society, begun in 1951 as the Guild of Contemporary Bookbinders, adopted a more structured organisation and a formal constitution in 1968 under its present name of Designer Bookbinders (Charity Reg. No. 282018).

The objects of the Society are twofold: the preservation and improvement of the craft and design of fine bookbinding through the encouragement, exercise and maintenance of standards; and the promotion of public interest in the craft and design of fine bookbinding. These aims are furthered by means of exhibitions, public lectures and masterclasses; the publication of relevant books, periodicals and catalogues; and the organisation of an annual bookbinding competition.

Membership of the Society is open to all. It is made up of four categories of membership, with Fellows and Licentiates being the exhibiting members. For more information on membership and projects, please visit our website: www.designerbookbinders.org.uk

ACKNOWLEDGEMENTS

Designer Bookbinders would like to thank the following sponsors for their generous support:

THE COMPETITION

Mark Getty
Michael & Louisa von Clemm Foundation
Maggs Bros Ltd

THE USA TOUR

Bonhams
Friends of Designer Bookbinders

DESIGNER BOOKBINDERS INTERNATIONAL COMPETITION

SIR PAUL GETTY BODLEIAN PRIZES

FIRST PRIZE £7,500 (binding given to the Bodleian Library)
SECOND PRIZE £3,000 (binding given to the Getty Collection at Wormsley)

DESIGNER BOOKBINDERS DISTINGUISHED AWARDS

Twenty-five sterling silver bonefolders, engraved with the binder's name, awarded for the twenty-five best bindings.

INCLINE PRESS AWARD

£250 presented by the publishers of the set book *Water* to the binder whose design most reflects their ideal for a trade edition of the book.

JUDGES

Richard Ovenden	Keeper of Special Collections, Bodleian Library
Tom Phillips CBE, RA	Artist
Edward Bayntun-Coward	Antiquarian book dealer and collector
Faith Shannon MBE	Fellow of Designer Bookbinders
Jeff Clements MBE, MDE (Hon)	Fellow of Designer Bookbinders

SET BOOK

A limited and numbered edition of poetry in a variety of European languages interpreting the theme of water, *Water* incorporates original prints by Clare Curtis, Bert Eastman, Rigby Graham, Eric Hasse and Paul Kershaw, as well as a double-page suminagashi by Victoria Hall, and a marbled wave from Ann Muir. The book is printed on acid-free Zerkall paper in a Garamond typeface, page size 255 × 190 mm, in six four-sheet sections, making a total of ninety-six pages. Printed and published by Incline Press, Oldham.

Foreword

MARK GETTY

My father began collecting bookbindings while he was still a young man, and at a time when the great binding collections formed by Major Abbey and other private persons of an earlier generation were coming onto the market. His collection of historic bookbindings was able to grow rapidly, and soon became augmented with bindings by the fine bookbinders of the late nineteenth and twentieth centuries, from Cobden-Sanderson onwards, including the great French designer bookbinders like Bonet and Martin. My father was also active in commissioning designer bookbindings and therefore added the work of living binders to those of the great binders of the past.

I am therefore delighted to have had the opportunity to sponsor this competition and in particular to have sponsored the top prizes in honour of my father. The Sir Paul Getty Bodleian Bookbinding Prize recognises the best current bookbinding in the world, and it is fitting that the Bodleian Library and the Library at Wormsley should add these two prize books to their collections, and that the name of Getty should continue to be associated with the most creative work in one of the most compelling fields of contemporary art and craft.

Preface

SARAH E. THOMAS

The Bodleian Library is honoured to be associated with the Designer Bookbinders International Competition and with the Sir Paul Getty Bodleian Bookbinding Prize.

From the earliest times, the Bodleian Library has taken bookbinding seriously. Many manuscripts and printed books acquired by the Library in the early days of its existence were kept in their original covers. Many new books, acquired in sheets, were sent to local binders to be bound. In later centuries, through generous donors like Francis Douce, the Bodleian began to acquire bookbindings as important historical artefacts and as examples of the book arts in themselves. In 1979 John Ehrman gave his father's magnificent collection of old and new bindings as part of the Broxbourne Library gift, adding a new dimension to the Bodleian's collections: designer bookbindings.

In hosting this exhibition we make an important statement about the Bodleian Library's continuing commitment to the arts of the book in general, and to the importance of bookbinding, old and new, in the life of a great research library. As researchers are increasingly interested in the material culture of books, so we recognise the importance of maintaining the skills and encouraging the creativity in bookbinding that have been a feature of the book for almost two thousand years. We are enormously grateful to Mark Getty for his generosity in supporting the Bodleian Library and Designer Bookbinders, and are glad to

work with a group of other committed and generous donors who enable our work in this area to continue.

The Bodleian Library would like to pay tribute to the hard work of Jeanette Koch, Lester Capon, Simon Eccles and their colleagues in Designer Bookbinders, for their sterling work to make this exhibition and publication happen. We should also like to thank the judges of the competition: Faith Shannon, Jeff Clements, Tom Phillips, Edward Bayntun-Coward and Richard Ovenden, for selecting the winning entries from the 240 submissions.

The Sir Paul Getty Bodleian Bookbinding Prize will now be a regular feature in the bookbinding world, and we look forward with eager anticipation to the next competition.

Sarah E. Thomas, Bodley's Librarian and Director of Oxford University Library Services

Introduction

LESTER CAPON

Designer Bookbinders has run an annual bookbinding competition since 1975, when it took over the responsibilities for the Thomas Harrison Memorial Competition. This was always confined to entrants working in Britain. Now we are delighted to organise this, our first international competition.

Many years ago we instigated the set book for our annual competition (whilst in addition keeping an open choice category). The set book has proved very successful, and we decided it was appropriate for this project also. Finding a suitable book was essential, so we approached the Fine Press Book Association and asked any interested private presses to submit ideas. Incline Press presented us with *Water*, a book they were just about to put into production. Everything was right for us with this book – an anthology of poems in several languages with images that complement the poems without having to illustrate them. The texts are printed to allow for a redistribution of the sections. This freedom invites the binder to be inventive with structure and offers a wide scope for design interpretation. The size is perfect and we knew that we could trust the long-established Incline Press to produce an attractive book, well printed and on good paper.

A major bookbinding competition is an exciting prospect. We are able to view a tremendous variety of approaches to the art of the hand-bound book. This being an international competition we can look for national characteristics.

We can assess possible influences from each country's society and culture. Bookbinding, like all art and crafts, can be coloured by the political and economic background from which it grows. We cannot escape our working environment, and why should we want to? It does not stop us from taking inspiration from wherever and whomever we like.

I hope that you will enjoy looking at this wide variety of modern approaches to the art of the hand-bound book. There are bindings steeped in tradition together with experimental structures. There are the reserved and the flamboyant, the serious and the humorous. They are all of our time and are part of our contribution to the continuing history of bookbinding, which is flourishing.

Our collaboration with the Bodleian Library began in 2005, when they approached Designer Bookbinders with the idea of contributing a twenty-first-century angle to their planned exhibition of historical bindings. We had already started developing plans for an international competition, and after preliminary talks the Bodleian enthusiastically embraced this as being the perfect vehicle to show current trends in contemporary bookbinding worldwide. This catalogue is therefore designed to complement their exhibition 'An Artful Craft: Fine and Historic Bookbindings from the Broxbourne Library and Other Collections'. Working with the Bodleian has been a great pleasure, and our gratitude goes to Richard Ovenden and his staff, Madeline Slaven and her exhibition team, and Deborah Susman, Samuel Fanous, and all in their publications department. Their professionalism and cooperation at all levels have contributed hugely to the success of this event.

Our sincere thanks go also to Maggs Bros for sponsoring the production of the specially commissioned silver bonefolders awarded to the Distinguished winners.

Our thanks go especially to Mark Getty, who has taken a great interest in this project and generously given us the means to make this competition, exhibition and publication such a success. He has helped us in the name of his father, Sir Paul Getty, who was a generous and knowledgeable patron of bookbinding, whom the community of modern bookbinders holds in the highest esteem.

Finally, I would like to thank all the entrants. There was a great response to the announcement of this competition and we can see in these pages evidence of an 'artful craft' very much alive.

Lester Capon, President of Designer Bookbinders

Prizewinners

First prize

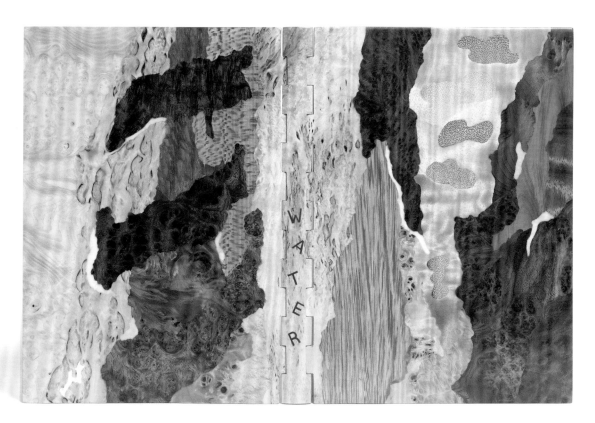

1 ALAIN TARAL *France*

Binding made of pear wood covered by Karelian birch veneer. Decoration of 'fusion' marquetry, made of many different precious wood veneers including palm tree, yew, bubinga, lati, plane tree, amboina, elm burrs, thuya and faiera. Wooden joints with steel axis. Suede flyleaves. Marquetry title. Wooden slipcase covered by Karelian birch veneer. Water comes to us from rocks, from mother earth, but also from clouds, sometimes from tears… at the beginning just a few drops that then come together to form streams and lakes.

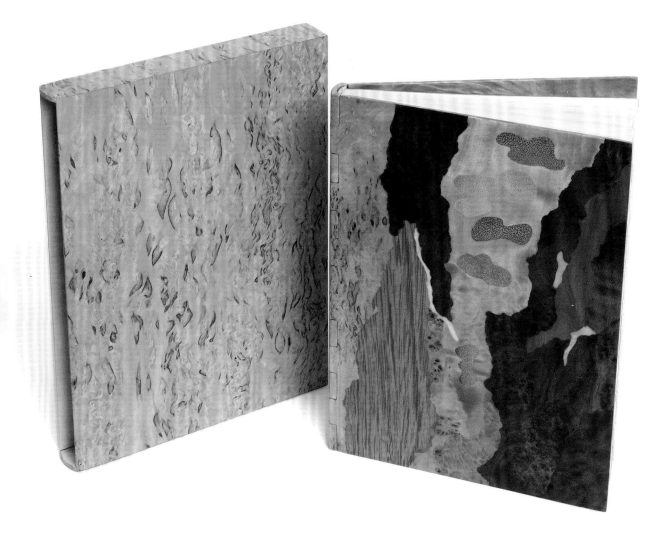

Second prize

2 JENNI GREY *United Kingdom*

The pages have been divided into two bindings: 'Water' and 'Waterborn'. Machine-embroidered grey Dypion-style fabric and airbrushed endpapers feature on both bindings. In 'Water', sterling silver wire fixings and etched acrylic, which creates shadows on the endpapers, are the predominant materials. The fold-out container incorporates information about both books and has shell button fastenings. The design was inspired by the light and shade created by sun and clouds on the surface of the sea, and echoes the marbling forms in the text.

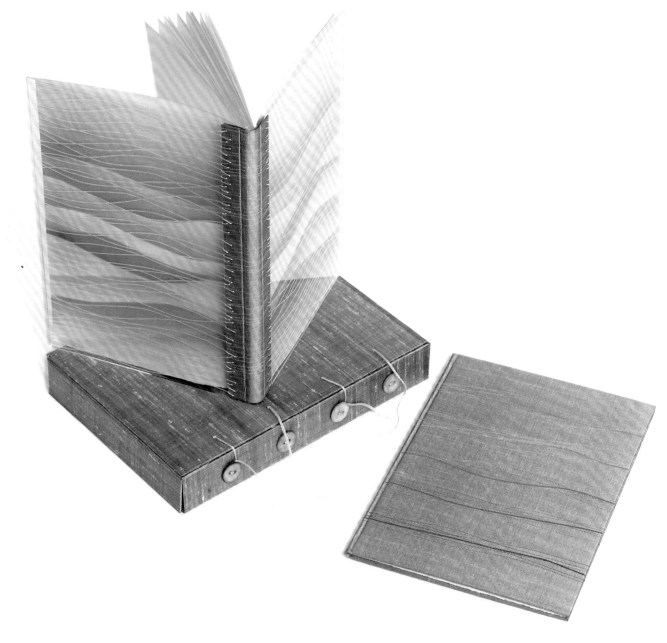

Distinguished winners

3 ANNIE BOIGE *France*

Bound in waxed white calf with underlays of sanded shagreen. Onlays of dyed calf and brown Oasis goatskin. Four tabs of white calf on foredges. White calf doublures and grey/blue suede flyleaves.

4 JAMES BROCKMAN *United Kingdom*

Concave spine binding with double hinge joints; spine frame of enamelled silver and brass; gold paper loose guards with a primary sewing of blue thread; a secondary sewing of fine nylon attaches the spine frame. Covered in cream Levant with leather onlays, tooled in three shades of gold and palladium leaf. Blue goatskin doublures with title picked out in gold.

5 EDGARD CLAES *Belgium*

Bradel structure. Spine covered in brown goatskin with snakeskin straps glued onto the endpapers and forming the board attachment. Boards of tulip wood veneer over fibreboard. The design, cut by hand into the veneer, is based on compasses and sextants.

8

6 ANNE-LISE COURCHAY *France*

Bound in full parchment with multi-coloured parchment marquetry. Multi-coloured sewn endbands and striped endpapers.

7 DOMINIQUE DUMONT *France*

Limp binding in midnight blue suede. Multi-coloured glazed goatskin onlaid strips with resin waterdrops. Lettered in purple on spine. Suede flyleaves with purple goatskin onlays. The design represents tall grasses moistened with dew.

8 BENJAMIN ELBEL

France

Bound in full white calf incorporating a bath plug on front board with black lettering. Removal of the plug reveals the end of the title under the transparent endpaper.

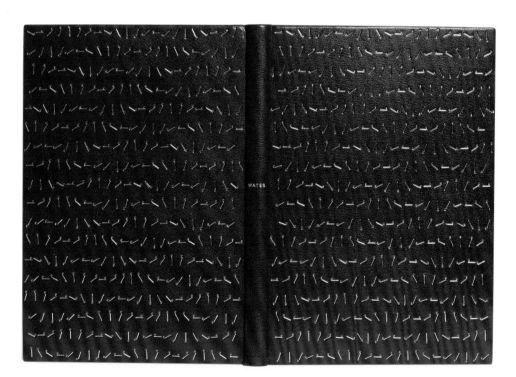

9 ANNETTE FRIEDRICH United Kingdom

Bound in full red goatskin, title in silver foil on spine. Tooling in silver and green/blue foil, using lines and dots that rotate around each other. Sewn red silk endbands and silver top edge. Plated red goatskin doublures with silver foil tooling and hand-dyed yellow flyleaves.

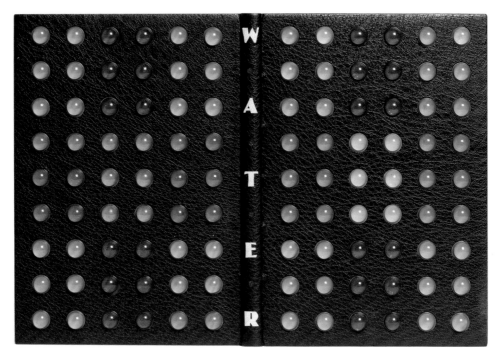

10 EDUARDO GIMENEZ *Spain*

Bound in black buffalo skin; insets of acrylic painted silicone drops. Black buffalo doublures and red suede flyleaves. Titled in pale blue leather onlays with red leather onlaid circles.

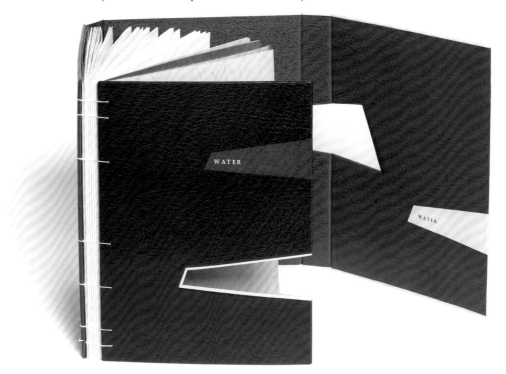

11 KÜLLI GRÜNBACH-SEIN *Estonia*

Bound in alum-tawed goatskin and blue Oasis goatskin. Back board extended to triple width of book to form flap; cut-out shapes edged in contrasting leather. Blue goatskin inlay and titling in white on front board. Alum-tawed goatskin inlay and titling in black on inside flap. Japanese paper doublures and stepped endpapers.

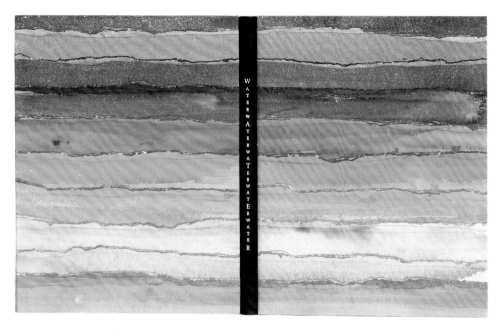

12 PER-ANDERS HÜBNER *Sweden*

Simplified binding with blue goatskin spine, tooled in white. Layered watercolour-painted paper boards. Sewn endbands. Blue Japanese paper endpapers.

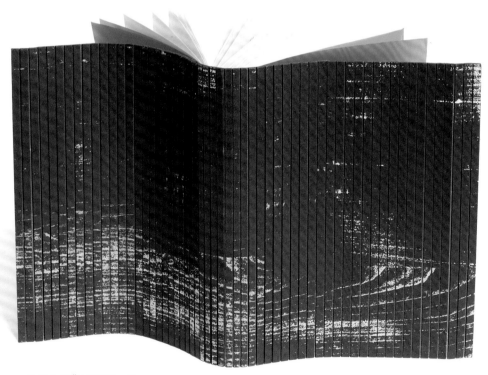

13 LORE HÜBOTTER *Germany*

Non-adhesive binding with a sand-blasted wooden plate brushed with linocut printing ink and printed on black board. Board slit into strips, glued on a dyed paper to which the sections are individually sewn.

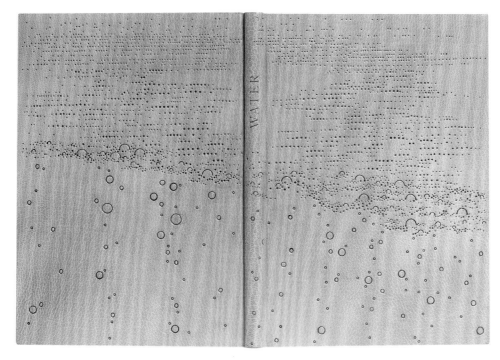

14 JANA KADEN *Germany*

Full grey/green goatskin with blind tooling. Lettered in blind on the spine. Housed in an oiled walnut box with three glass lenses and brass rings partly revealing the front board.

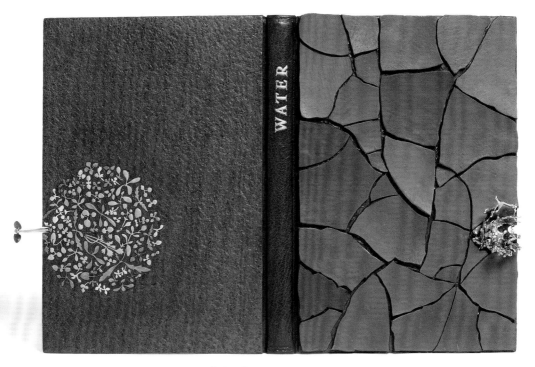

15 GEORGE KIRKPATRICK *United Kingdom*

Bound in calf, various goatskins with palladium tooling, silver rhodium plated to prevent tarnish, and gilded brass. A splash lands on the dried mud cracks, soaks through to the back cover where Eve's dormant seeds spring to life. Among them is one golden seedling which grows towards the water source, forming the book clasp.

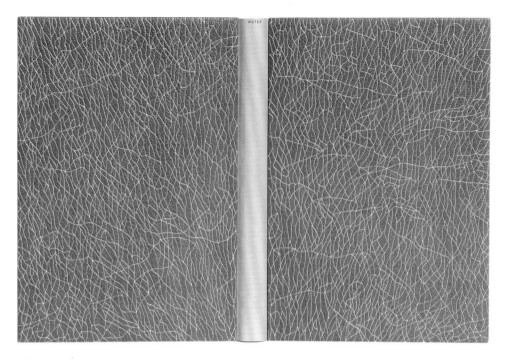

16 IREEN KRANZ *Germany*

Simplified binding with lilac boxcalf spine tooled in red. Boards covered in grey Morocco goatskin with grey and pink tooling. Red leather endbands and top edge coloured grey. The linear foil tooling on the boards follows the spreading grain and occasionally crossing-points are highlighted by pink dots.

17 RITA LASS *Germany*

Open structure binding with blue paper spine and blue paper boards embossed with green foil using original stamps from the Dorfner bindery in Weimar. Blue leather endbands. Top edge coloured in lilac. Blue paper doublures and salmon-pink flyleaves.

18 MECHTHILD LOBISCH *Germany*

Paper binding: inkjet printing on Chromolux over a very low relief of diagonal waved lines. Doublures and endpapers printed with inkjet on Chromolux. Folder: Chromolux with inkjet printing, containing cardboard frame with mini-CD in an envelope. Inner folder: Barcham Green blue handmade paper with inkjet printing, containing Leopold Graf zu Stollberg's poem 'Auf dem Wasser zu singen', and its English translation, set to music by Franz Schubert. A variety of motifs appear on covers, doublures and endpapers. Container: turquoise cloth and white paper with blue inkjet print, lined with turquoise Amaretta.

19 KAIA LUKATS *Estonia*

Limp binding in dark blue, heavily grained boxcalf with machine sewing around edges. Titled in blind on front board. Blue suede doublures. Sections wrapped round in a variety of blue papers.

20 BRUNA MAFFEI *Italy*

Stub binding in various blue papers and Perspex. Embossed lettering on front cover. White paper flyleaves with recessed blue paper visible through the Perspex. The wavy lines and colours of the design symbolise a waterfall.

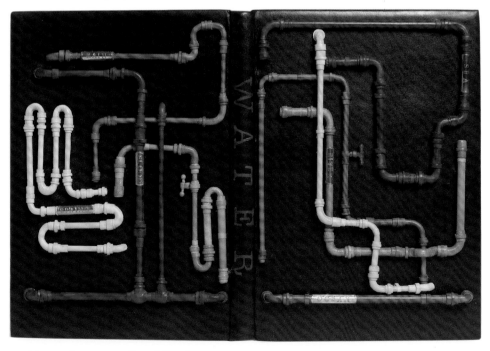

21 MARY NORWOOD *United Kingdom*

Bound in black calf with arrangement of domestic water pipes, made from hand-dyed calf and goatskin, wound onto framework of timber and clay, and secured by leather straps. Brass labels stamped with names of water sources. Sewn on laced-in linen tapes with illustrations guarded in.

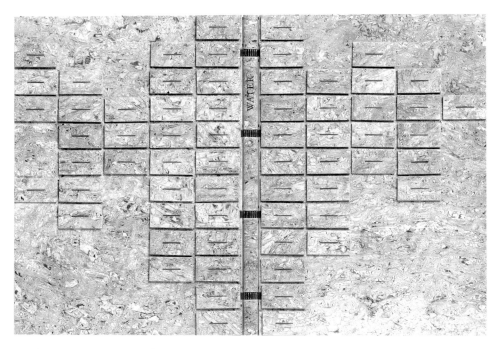

22 ANDREA ODAMETEY *Germany*

Binding of pasteboard made from aquatic sports magazines pasted together and polished with emery. Book sewn onto leather tapes visible between the spine segments. The cover is decorated with movable rectangles, connected with leather straps which remain visible as blue lines.

23 RITSUKO OHIRA *Japan*

Bound in light blue goatskin with silkscreen printing. Palladium, white and coloured tooling. Japanese paper endpapers with palladium tooling. Sewn double silk endbands.

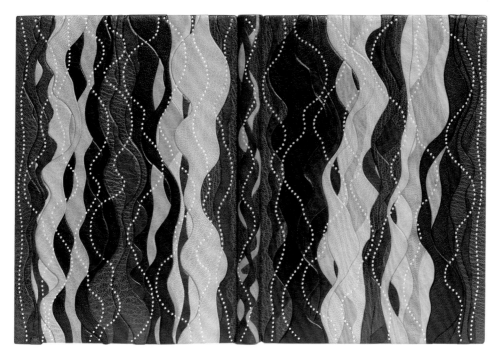

24 DOMINIC RILEY *United Kingdom*

Covered in dark green, light and dark blue goatskin over cushioned boards. Onlays of medium blue and light green goatskin. Silver tooling. Painted top edge. Silk sewn endbands. Light blue goatskin doublures with green onlays and silver tooling. Green suede flyleaves.

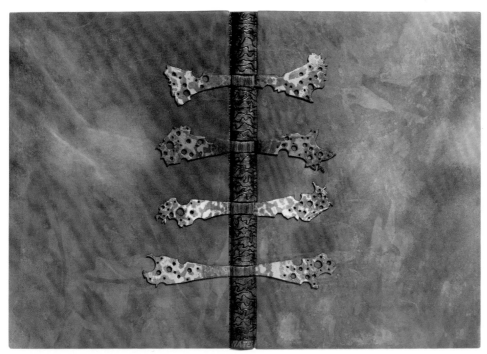

25 DAVID SELLARS *United Kingdom*

Spine covered with Brazilian goatskin with bronze and black tooling. Sides covered with Dutch vellum. Sewn on linen tapes with secondary sewing on linen covered with frog skins. Double sewn endbands. Painted top edge. Endpapers and doublures marbled by Jill Sellars to binder's design brief.

26 CHRISTINE SIEBER *Germany*

Leporello structure with polycarbonate covers varnished with car lacquer using airbrush techniques. Rotating sections of multi-coloured airbrushed acetate are articulated within the front and back covers.

27 THERESA WÜNSCHE *Germany*

Exposed structure with paper spine and boards covered with fixed acrylic foil layers covered with varnished, perforated, transparent paper. Pearl bead endbands. Blue paper doublures and cream handmade paper flyleaves. Black drop-back box with double bottom filled with little metal balls to create the sound of waves receding over pebbles.

Incline Press award

28 MARJA WILGENKAMP *The Netherlands*

Cover built up of paper and museum boards. Collage of small torn Arches paper strips, edges painted in water-like colours, and small strips of monoprints. Relief of five water drops on front cover. Paper endbands. Title formed by torn paper pieces on spine. Hand-decorated acrylic ink endpapers. Design inspired by trickles of water along a window, and by rainfall for the endpapers.

Exhibitors

29 IDO AGASSI

Israel

Bound in full brown leather with two shades of green leather onlays. The boards are connected in a 'tongue and slot' attachment. Running throughout the curves on both sides of the binding are 5 mm PVC irrigation dripper tubes, with T-shaped sprinklers attached. Spanish marbled endpapers.

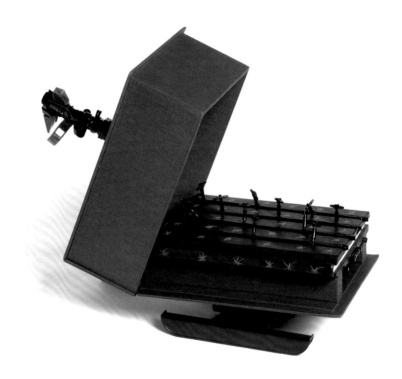

30 CRISTINA BALBIANO D'ARAMENGO

Italy

Limp cross-structure non-adhesive binding with structural headbands. Cover of Khadi paper decorated with a net pattern by Carmencho Arregui. Sewn with fishing line. The whole structure is held by cut bands inserted into slots. The prints are mounted to show their colours on the front edge.

31 MARGOT BANSARD

France

Simplified binding in dark and light blue French calf. Endpapers are made of light blue pastel paper. The cut-out design on the cover suggests the movement of a wave.

32 GLENN BARTLEY

United Kingdom

Bound in scarf-jointed burgundy and grey Harmatan goatskin. Crimson and recessed blue goatskin onlays edged in cream acrylic. Doublures of crimson goatskin and flyleaves of grey suede and blue Mingei paper. Edges airbrushed with aqua blue acrylic. Gold and blind tooling.

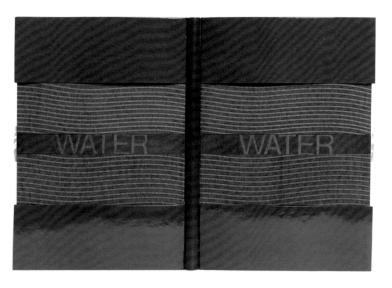

33 FRANÇOISE BAUSART

Belgium

Open-joint structure sewn on leather tapes. Undulating shaped boards are decorated with blue varnished calf and hand-painted Kromekote in different blue colours. A piece of mother-of-pearl is inset on foredges. The inner boards are dark green calf with flyleaves in hand-painted Japanese Gampi paper.

34 SIMONE BENOÎT-ROY

Canada

Full pale green goatskin binding with textured and gold onlays. Sewn endbands and coloured top edge. Decorated endpapers with gold onlays.

35 MARLYN BONAVENTURE

USA

Bound in full dark blue goatskin. Gold and blind tooling. Recessed panel of collaged papers and gilded leather Pisces zodiac sign. Top edge coloured and gilt. Sewn endbands. Paste-paper endpapers by Claire Maziarczyk.

36 STUART BROCKMAN

United Kingdom

Transparent vellum over watercolour painting of desert scene with mirage. Split board binding with French groove. Inside boards incorporate water-effect mirrors which reflect blue paste-paper endpapers sprinkled with gold leaf. Mirage and lettering tooled in palladium leaf. 'Sun glint' gold tooling and eleven solid gold bosses attached with stainless steel pins. Boards edged with black goatskin sprinkled with gold leaf. All edges gilt.

37 ANDREW BROWN
United Kingdom

Covered in blue, green and grey goatskin. Top edge of boards shaped. The blue and green area comprises overlapped pieces which have been specifically onlaid and sanded to give a fluid finish. This then merges with the grey area, which is inlaid, puckered and spells the title. There is a blind coronet splash on the front, spine and rear. Green goatskin doublures with grey sanded onlays. Turquoise suede flyleaves.

38 HANNAH BROWN
United Kingdom

Simplified binding covered in fair goatskin with miscellaneous coloured and back-pared leather onlays. Machine- and hand-sewn lily pads. Hand-pierced brass lily pads and flower centre, sprayed and lacquered, and hand-pierced bookmark end. Handmade hand tools for gold, blind and carbon tooling.

39 JOHN BURTON
United Kingdom

Bound in pale blue goatskin with dark brown and black inlays, onlays and black tooling. Hand-painted doublures and endpapers. Edges coloured blue with gauffered silver tooling. Sewn endbands.

40 Eliška Čabalová-Hlaváčová

Czech Republic

Full vellum binding with sculptured shell-shaped boards. The natural veins of the vellum and mother-of-pearl impression on the spine provide the decorative aspect. Edges coloured and polished. Mother-of-pearl paper doublures and flyleaves.

41 Jan Camps

Belgium

Full leather binding in hand-stained calf. Meeting guards in blue and white. The airbrushed leather is partly depolished. On the two boards an inlay of the same calf with blind tooling. The inlay is partly depolished and varnished. Title and corners of the inlay tooled in foil. Green calf doublures and green suede flyleaves.

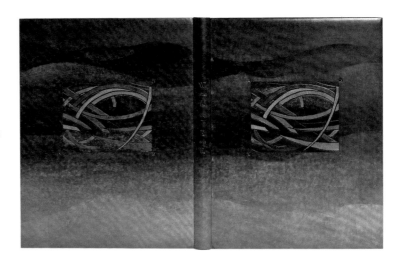

42 Lester Capon

United Kingdom

Bound in full pierced vellum. Underlays of hand-stained and painted handmade paper. Gold tooled on boards and lettered in gold on spine. Gouache top edge. Silk endbands. Paste-paper flyleaves and Mingei paper doublures.
(*Organiser's non-competitive entry*)

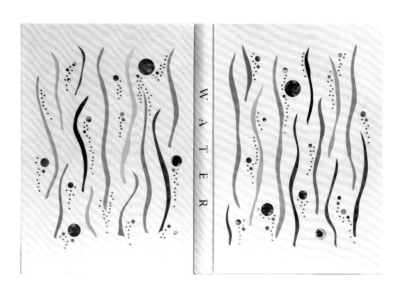

43 KRISTOFFER CARLSSON

Sweden

Hand-decorated paste-paper binding with black leather edges. Graphite top edge. Silver foil decoration. Matching paste-paper endpapers.

44 MARK COCKRAM

United Kingdom

Hand-dyed full goatskin binding with gold tooling. Linocut endpapers made by binder with reduction four-colour linoprint. Design based on rain falling on the lake and decorative carp at the Kinkakuji Golden Palace, Kyoto, Japan.

45 EMMA COLL

France

Exposed sewing binding with Carolingian sewing on leather tapes. Spine covered in pigskin and sculptured boards covered in vellum. Lettered on front board. Wrap-around pigskin thongs and bone clasp. White leather doublures.

46 STEPHEN CONWAY

United Kingdom

Bound in full black pigskin with panels of stained calf, paper, parchment, and reconstructed leather parings painted with black acrylic. Tooled in black on boards. Lettered in black on spine. Hand-decorated paste-paper doublures.

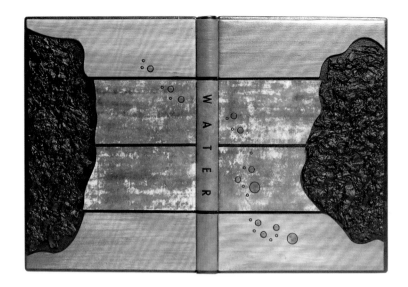

47 HÉLÈNE DELPRAT

France

Bradel binding with tabs covered with violet buffalo leather. Titled in white foil. Boards covered in sandpaper hand-decorated with acrylic violet ink and watercolours. Mirror paper doublures partly embossed with sandpaper shapes. Purple suede flyleaves.

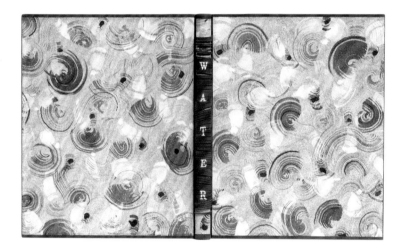

48 CLAUDIA DETTLAFF

Germany

Bradel binding with black goatskin spine onlaid with coloured leathers. Tooled in blind on spine. Green goatskin boards with recessed stained paper and leather panels, tooled in foil.

49 INGELA DIERICK

Belgium

Bradel blue paper binding with multi-coloured Japanese paper underlays. Sewn double endbands. Decorated Japanese paper endpapers.

50 NICHOLAS DUNN-COLEMAN

United Kingdom

Split board binding, paper sides, cloth spine. Decorated with watercolour, printing ink and dye.

51 MARTINE DURAND

France

Bound in full green/grey boxcalf painted with printing ink, and inlays of same leather, painted according to the illustrations of the book. Endpapers decorated by the binder.

52 Ragnar Gylfi Einarsson

Iceland

Boards covered in blue Oasis goatskin decorated with catfish leather. The spine is covered with salmon skin and tooled in silver. Graphite top edge. Leather endbands.

53 Paola Fagnola

Italy

Bound in light blue calfskin and Perspex. Sewn on hemp cords with light blue thread. Top edge decorated with sprayed acrylics. French endbands. Feathered calfskin doublures. Flyleaves in paper marbled with printing inks and handwriting.

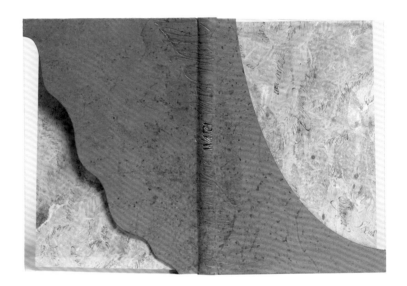

54 Isabelle Faure

France

Limp binding in alum-tawed goatskin with alum-tawed raised onlays partially stained, evoking the transition of water from solid to liquid. Titling on front board. Blue suede contoured doublures and flyleaves.

55 ERI FUNAZAKI

United Kingdom

Bound in full black goatskin with inlays of hand-dyed calfskin. Laminated vellum inlaid into cameo-style front board. Double endbands. Top edge coloured. Hand-printed doublures and flyleaves. Moon gold tooling. Cheeky frogs are hand-printed on some pages. Some illustrations are removed from text block and housed in a compartment in the drop-back box.

56 LAPO GIANNINI

Italy

Bound in pink Morocco goatskin with inset of blue cathedral glass. Gold and blind tooling. Top edge coloured. Gold lettering on spine. Pink leather endbands. Marbled paper doublures and flyleaves.

57 CHRISTINE GIARD

France

Limp binding in cream rubuck on the boards and blue marbled rubuck on the spine. Raised onlays of blue rubuck suggests seaweed forms underwater.

58 Anne Giordan

France

Bound in full beige boxcalf inlaid and onlaid with stained and decorated calfskin. Titled in green and white on the spine. Sewn endbands and decorated top edge. Boxcalf doublures and paper flyleaves typo-printed in a pebble design. Cover design inspired by river and banks.

59 Simon Haigh

United Kingdom

Bound in full blue goatskin with onlaid coloured and gold lines with burnished gold areas. Cushioned boards, paste-paper endpapers by Victoria Hall, whose suminagashi illustration forms part of the text. Top edge coloured. The design gives the impression of clouds raining onto rolling water below.

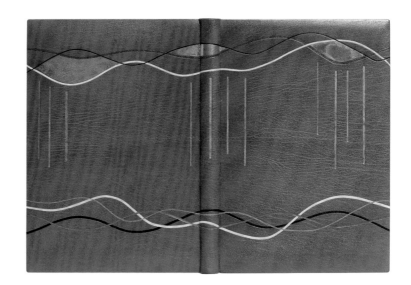

60 Rene Haljasmäe

Estonia

Full blue calf binding coloured with Luganil paint over fishnet. A variety of metal spinners attached to both covers. Secondary sewing with fishing line and title blind-tooled on spine. Pike- and perch-skin doublures.

61 HEATHER HARRISON

United Kingdom

Case binding in library buckram, dyed and painted, with inlays of leather, silk and holographic foil. Endpapers of suminagashi and Ingres.

62 ANNETTE HAVEKOST

Germany

Full leather binding in dark blue Oasis goatskin. Blind and silver foil tooling on the covers. Sewn light blue endbands. Hand-dyed endpapers in various shades of blue.

63 KATE HOLLAND

United Kingdom

Covered in full white alum-tawed calf over sculptured boards with a reverse offset printed design depicting the water cycle. Boards are hand-coloured with blue and tooled in silver. Edges coloured. Sewn endbands in grey, blue and silver. Decorated endpapers.

64 DEREK HOOD

United Kingdom

Covered in multiple onlays and inlays using various textured leathers, the binding was constructed objectively by utilising the lines, shape and forms acquired by manipulating and dissecting the symbol H_2O. The resulting abstract image echoes the interplay between light and shadow on moving water. Edges are hand-gilded to complement the fluidity of the design.

65 FREYA HUNOLD

Germany

Spine covered with green goatskin. Japanese paper boards with vellum tips. Endpapers coloured with airbrush technique. Dark blue coloured edges. Sewn endbands. Blue vertical title.

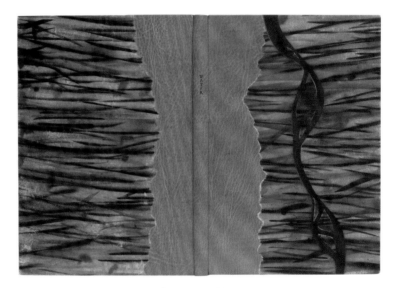

66 DIANA ILLINGWORTH-COOK

United Kingdom

Coptic-style binding using unsupported link stitch between fused bullseye glass covers. The spine is decorated with a silk thread waterfall, and binding is housed in a felt pouch. The design was inspired by the ripples and movement of water.

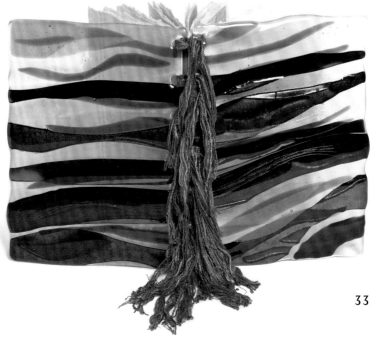

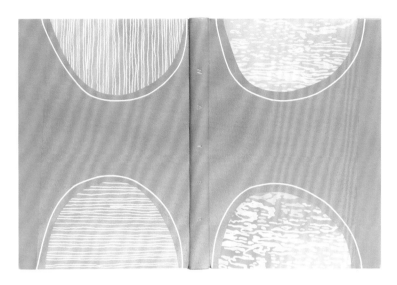

67 Angela James
United Kingdom

Bound in natural goatskin,
airbrushed grey. Back-pared
onlays of resist-patterned natural
calf, airbrushed using acrylic
inks. Inlaid airbrushed calf on
foredges. Goatskin doublures
with inlaid calf. White gold
lettering and white tooling.

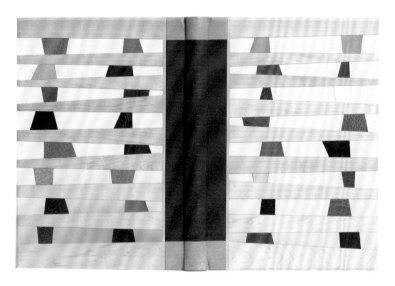

68 Peter Jones
United Kingdom

Spine and leather joints of scarf-
jointed blue and biscuit goatskin
with blind tooling. Boards
constructed from alternating
tapered strips of maplewood and
clear acrylic sheet with leather
inlays, threaded onto carbon
fibre rods. Scarf-jointed and
laminated Mingei endpapers
with additional part-sheets
interleaved with whites leading
into the text.

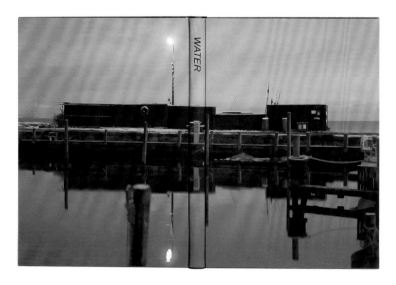

69 Mette Humle Jørgensen
Denmark

Rubow binding in dark blue
goatskin incorporating a
photograph of twilight at
Humlebæk harbour taken by
Roberto Fortuna. Gold-tooled
title on the spine. Painted top
edge. Sewn endbands.

70 SCOTT KELLAR

USA

Bound in aqua buffalo leather. Onlays of goatskin and gilt leather. Red silk endbands. Sprinkled salmon edges. Aqua Nepalese endpapers. The mesmerising interplay of reflected/refracted light with underwater objects, visually throbbing and magnified, is the theme of this design.

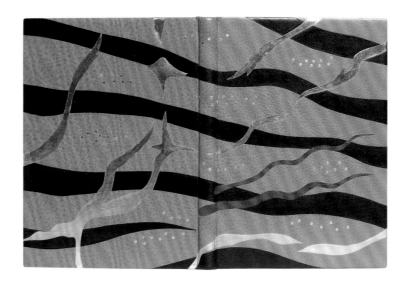

71 JENNIFER KLOSE

Germany

Full linen stub binding with sewing on front and back cover. Title embossed on front cover.

72 JEANETTE KOCH

United Kingdom

Book sewn on four vellum and resist-dyed lilac goatskin straps fastened with catgut. Matching leather-covered wooden rods on foredges with resin raindrops. Boards covered in transparent vellum over photo-transfer images. Surfaces covered in resin water drops. Hand-dyed silk endbands. Gouache-decorated top edge. Resist-dyed lilac goatskin doublures. Flyleaves decorated with photo-transfer images.

(Organiser's non-competitive entry)

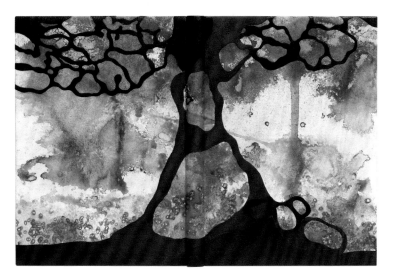

73 MIDORI KUNIKATA-COCKRAM

United Kingdom

Covered in paper decorated by binder with gouache and salt. Double hollow in goatskin and paper. Black goatskin and reversed goatskin onlay. Blind tooling on spine. All illustrations assembled into a final concertina section.

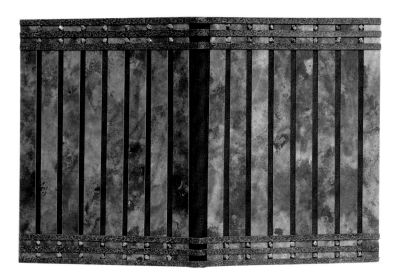

74 MIA LEIJONSTEDT

United Arab Emirates

Limp binding constructed of laminated, alternating strips of goatskin and dyed reindeer parchment. Pyrite onlays. Top edge painted black and tooled with pyrograph pen. Painted endpapers.

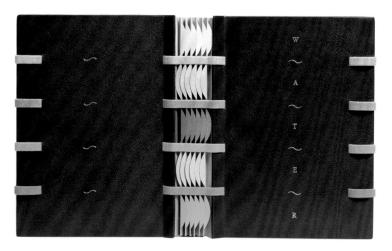

75 RUTT MAANTOA

Estonia

Concertina binding. Expanded spine, spine-pleat with cuts and fold-outs, fabric tape supports. Boards covered in dark blue goatskin with title tooled in silver on front board.

76 KAORI MAKI

United Kingdom

Bound in a decorated goatskin with headcaps in grey suede. Paper doublures and flyleaves hand painted by the binder with images representing the transformation of water. Plants, animals, and even we are formed of water. This 'wet-look' leather, found in a craft shop, inspired this design.

77 LENNART MÄND

Estonia

Open structure binding with secondary sewing through linen with alligator leather bands. Composite board covers carved with design and lettering.

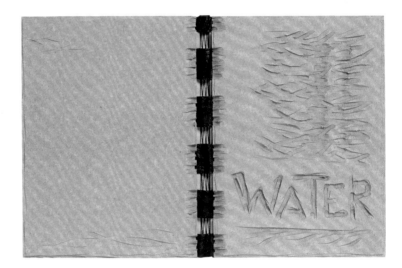

78 YUKO MATSUNO

United Kingdom

Bound in pieced black goatskin with underlay of Japanese gampi-shi paper hand-coloured with Sumi-e ink, white gold leaf inlays, black goatskin inlays with the title lettered in white gold. Top edge decoration, doublures and endpapers handmade with Japanese paper and hand-coloured gampi-shi onlays.

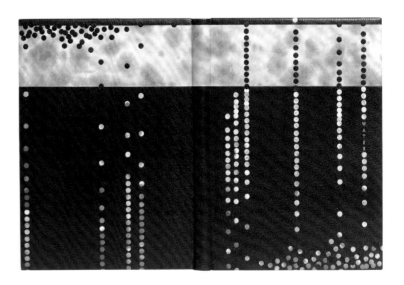

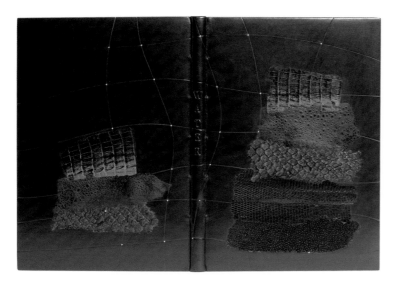

79 ROLAND MEUTER

Switzerland

Full leather binding in dark blue calf with onlays of aquatic animal skins. Tooled in gold and blind. Gilt edges and sewn endbands. Title on spine tooled in blind. Hand-dyed endpapers and suede flyleaves.

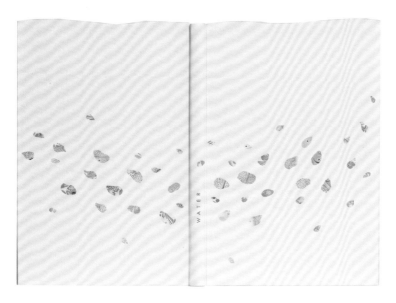

80 RUI MIN

People's Republic of China

Case binding with white paper, contoured top edge, and marbled paper inlays. Endpapers printed with handmade woodcuts on green f-color paper.

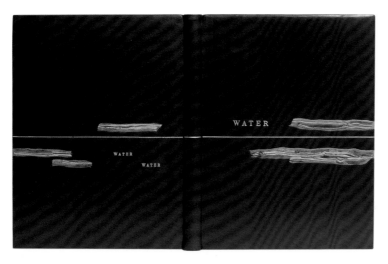

81 ANNE MONTANIÉ

France

Full binding in purple boxcalf with onlays of narrow strips of different leathers over an orange leather background. Doublures of soft calf and Japanese paper.

82 IKUKO NAKAJIMA

Japan

Stub binding in navy blue straight-grain goatskin inlaid with navy blue calf and ray. Decorated endpapers.

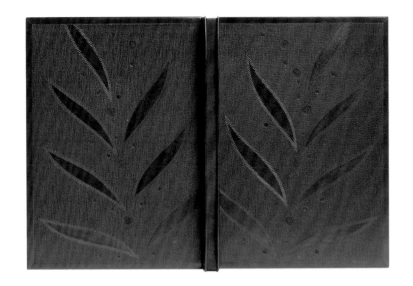

83 EIKO NAKAO

Japan

Limp parchment binding hand-stained underneath with indigo image of water and rain. Gilded polished clasp in the shape of a drop of water. Red foil title on front cover. All edges gilt. Paste-paper endpapers depicting water and rain.

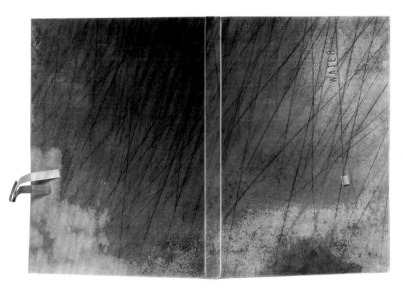

84 SUSANNE NATTERER

Germany

Exposed structure with purple and orange Oasis goatskin spine. Goatskin, snakeskin and paper striped boards. Moriki Kozo endpapers.

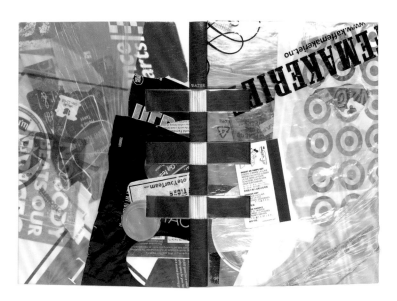

85 AMANDA NELSEN

USA

Blue goatskin covers this exposed-tape simplified binding, sewn-on water-bottle 'tapes' and attached to boards covered in sundry plastic materials. Endpapers contain pen drawings of the Mercator projection map circa 1943. Sewn silk endbands and watercolour-decorated edges describing the Mississippi river in North America.

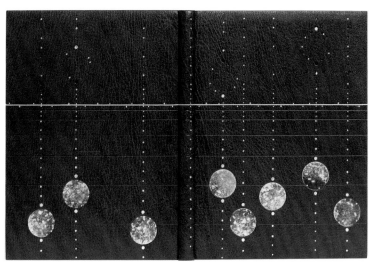

86 AYA NISHIO

Japan

Bound in dark blue goatskin with transparent vellum onlays recessed into boards. Blind and gold tooling. Gold tooling on and under vellum. Top edge gilt. Endpapers hand-tooled with gold.

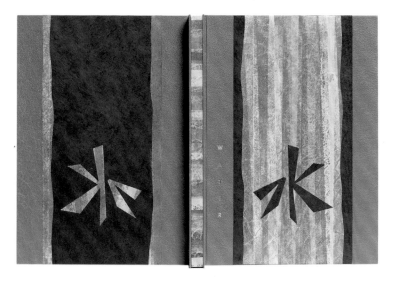

87 MICHÈLE NOURAÏ

France

Japanese-style binding in blue-grey buffalo. Onlays of coloured, sanded silk papers and Nepalese papers with an inset of the Japanese/Chinese ideogram for 'water'.

88 MANFRED OELMANN

Germany

Paper case binding with bookcloth edging at head and tail. Boards covered in paste-paper, inkjet-printed and wax-finished. Cover photo image by binder.

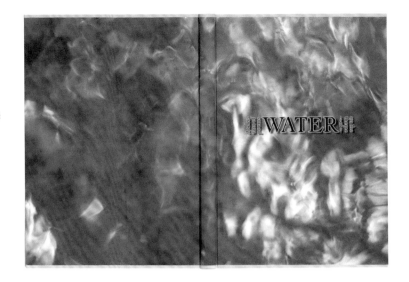

89 KAIRE OLT

Estonia

Non-adhesive binding with coloured sewing threads through suede spine. Boards covered in embroidered silk and beads. Dyed and embroidered Japanese paper doublures. Japanese paper flyleaves.

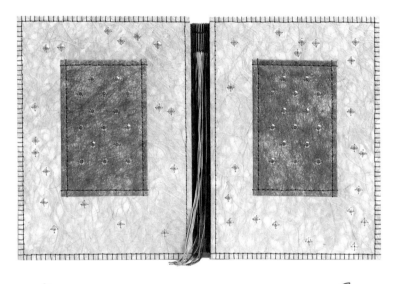

90 PATRICIA OWEN

USA

Split board boxbinding covered in green stained goatskin over sculptured boards. Sewn silk headbands and ultrasuede flyleaves.

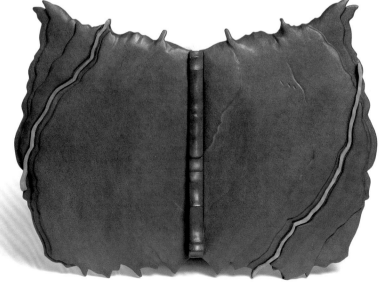

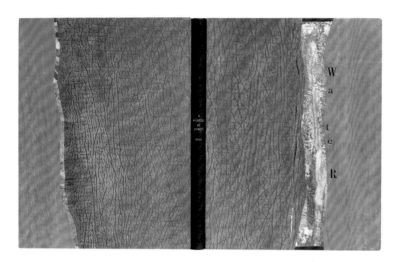

91 ADDA PAPADOPOULOS

France

Simplified binding. Purple Oasis leather spine lettered in silver. Boards covered in blue-green sharkskin and stained suede. Inlays of silver foil and tinted Kyoseishi Japanese paper. Titled in blue foil on front board. Silver rolled endbands. Purple suede doublures and decorated paper flyleaves.

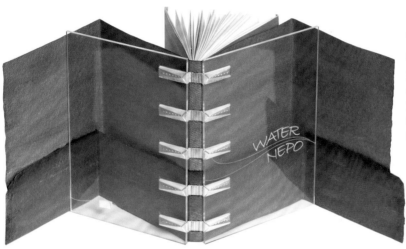

92 EVANGELIA PARLAVANTZA-TSITOURA

Greece

Perspex boards etched with title and attached by silver painted parchment bands with decorative secondary sewing. Textured stained paper flyleaves.

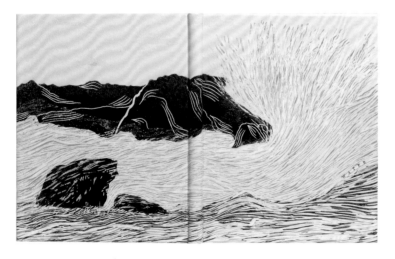

93 MIGUEL PEREZ FERNANDEZ

Spain

Bound in full ivory goatskin decorated with coloured linocuts continuing onto the leather doublures and suede flyleaves. Sewn two-colour silk endbands.

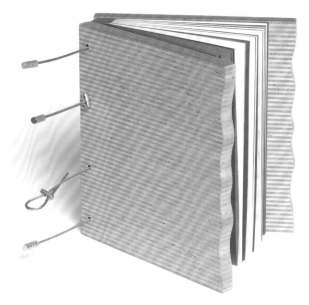

94 Tiina Piisang

Estonia

Boards covered in 2.8 mm birch veneer. Sections are interleaved with blue and grey Ingres paper and attached to boards with flexible steel rods and laser-engraved titling on their aluminium tips.

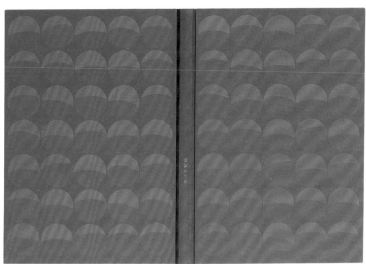

95 Anne Puls

Germany

Case binding with blue hand-dyed paper. Paper inlays and onlays on the boards. Titled in green foil on spine.

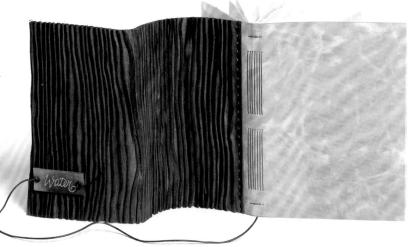

96 Jane Rannamets

Estonia

Limp long-stitch binding in yellow vegetable-tanned leather, with extended wrap-around corrugated turquoise leather flap. Title on leather panel attached by blue leather thongs.

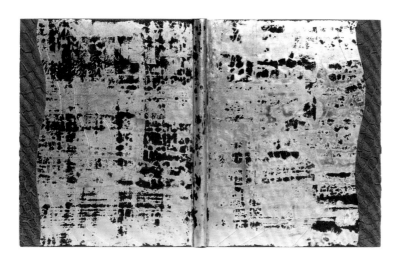

97 James Reid-Cunningham

USA

Bound in black calfskin decorated overall with palladium leaf. Boards decorated with impressed curvilinear lines, then edged in cow stomach. Textblock sewn with leather hinges, meeting guards and Nideggan endsheets decorated with suminagashi. Sewn front bead silk endbands. Endpapers and blank flyleaves trimmed to the shape of the cow stomach edging.

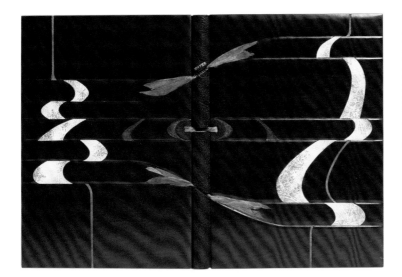

98 Eri Sakai

Japan

Exposed sewing on Japanese paper cords with dark red goatskin spine. Boards covered in red calf with embossed boxcalf and paper inlays. Crystal bead endbands and decorated endpapers.

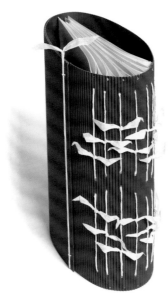

99 Elisabeth Schneider

Germany

Binding of flexible blue corrugated cardboard, wrapped white paper-strings, and a metal rod. Design evolved from technical and structural elements found in historic archival binding technique. Wrapped paper ties on the spine of the object, with their ends unwrapped and styled to give the impression of a flying flock of waterbirds.

100 JONAS SCHNEIDER

Germany

Scarf-jointed goatskin spine in
blues and greens. Tan goatskin
and paper onlays continuing
onto doublures. Sewn endbands.
Title tooled in white foil.

101 DAWN SKINNER

Canada

Bound in heavily grained
goatskin with back-pared onlays
of various dyed and sanded
goatskins. Sanded goatskin
doublures and suede flyleaves.
The design reflects the colours,
the reflections and the rock
pools of the northern Pacific
coast and the Rocky Mountains
lakes. The tones are a blend of
deep blues with occasional bright
flashes.

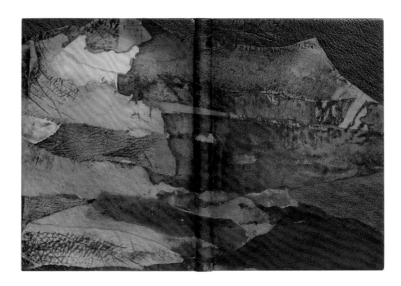

102 JAN SOBOTA

Czech Republic

Full green goatskin double
boards box binding. A coloured,
cast polyurethane 'waves'
structure mounted on front
board. Green leather doublures
and endbands. Lettered with
dark green and blue-green
goatskin onlays. Water drop
image painted in acrylic on
front doublure. Marbled paper
flyleaves.

103 ELLA SUMMATAVET

Estonia

Concertina binding in green goatskin with exposed coloured meeting guards. Recessed panel of coloured salmon skin and vellum cut-outs. Tooled in blue on spine.

104 MADOKA TAIRA

Japan

Bound in full blue goatskin with dyed raffia-grass, calf and snakeskin inlays. Lettering in silver on spine. Japanese paper doublures and blue suede flyleaves.

105 EDUARDO TARRICO VILLAFAÑE

Argentina

Bound in full cream Carabu leather, with raised and recessed blue stained onlays, sewn endbands, blue Carabu leather doublures and flyleaves with raised, sanded onlays.

106 YUKIKO UCHIDA

Japan

Brown Japanese paper textured spine with cactus thread. Cream textured Japanese paper boards with movable magnetic sculptured fish covered in red boxcalf. Dark blue Japanese endpapers. Flexible jacket of varnished wood.

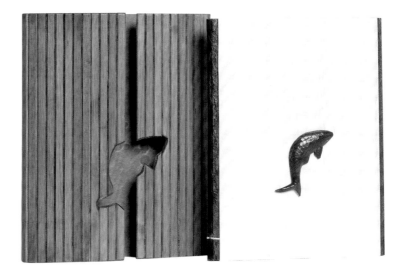

107 YOKO UENO

Japan

Simplified binding in turquoise calf, decorated with a four-coloured mosaic onlay and white enamel paint. Sewn endbands. Endpapers with paper cord underlay.

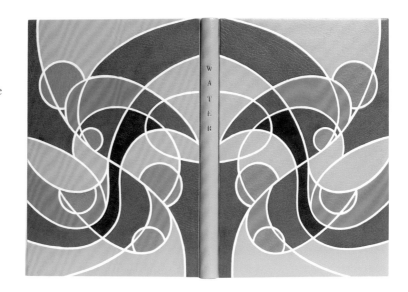

108 TOON VAN CAMP

Belgium

Bound in hand-dyed brown, black and red buffalo leather with kangaroo leather concertina guard and vellum titling label on spine. Recessed areas and text edges gilded in palladium. Suede doublures.

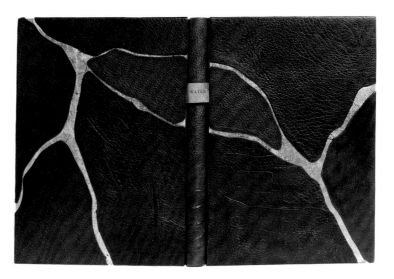

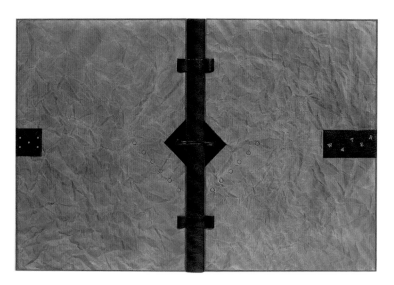

109 Berdien van Lieshout
The Netherlands

Exposed sewing binding with dark blue goatskin spine. Black leather thongs and straps laced into boards. Boards covered in blue decorated paper with black tooled circles. Onlays of black boxcalf and goatskin. Titled in blue on front cover. Blue Japanese paper endpapers.

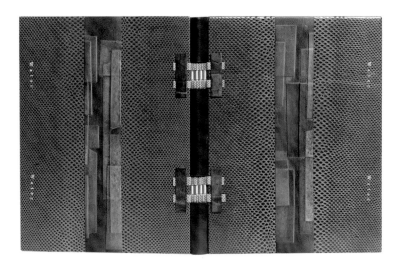

110 Julia van Mechelen
Belgium

Non-adhesive binding sewn on four thongs of Karung watersnake skin. Blue and white meeting-guards partially visible on the spine between two thongs. Dark grey calfskin spine. Boards covered with blue Karung watersnake skin. Vertical decoration on boards of pieces of calf coloured in blue tones. The same decoration in miniature is holding the thongs on the boards. Dark-grey calfskin doublures. White foil titling.

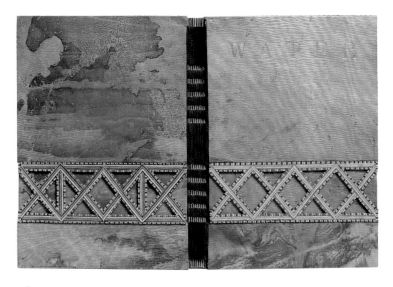

111 Tiiu Vijar
Estonia

Exposed sewing structure with blue boxcalf spine. Stained and marbled leather boards with multi-coloured leather mosaic panels on both boards. Decorated endpapers.

112 HANS VON ROTZ

Switzerland

Non-adhesive blue paper binding. Colour foil and lettering on both boards.

113 RACHEL WARD-SALE

United Kingdom

Spine and board edges covered with dark blue Harmatan goatskin. Boards, spine, covered with paste-paper made by binder with matching doublures and flyleaves. Full-thickness tan calf onlays, impressed with fishing net, applied to boards and doublures. Top edge coloured with acrylic paint. Double-core silk endbands in shades of blue.

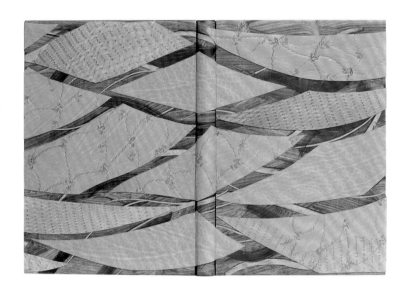

114 ROBERT WU

Canada

Danish millimetre binding. French chagrin leather edging and Oasis goatskin onlays. Graphite top edge. Original marbled graphics in watercolour by the binder. Title tooled in palladium and gold dots.

115 JULIANA WALKER

Germany

Open-joint structure. Sections sewn on vellum tapes with nylon thread. Relief-patterned boards covered with dark purple hand-dyed paper. Spine lettered in yellow. Lilac doublures. Flyleaves decorated with linocuts and stencilled pattern and fed through the gap at the joint and glued onto the spine.

116 KATERYNA YEROSHENKOVA

Germany

Paper binding with separately attached boards covered in multi-coloured paper strips. Onsets of glass stones on both boards. Tooled in silver on spine. Sewn endbands. Spine and endpapers lined with glassine paper.

117 JAN PETER ZIMMERLICH

Switzerland

Open-structure woven binding on parchment paper and polycarbonate tapes. Polycarbonate boards, fishbones simulating endbands and integrated into the function of the binding. Titled in black on paper chemise.

Non-exhibitors

Miyuki Abe

Japan

Non-adhesive stub binding incorporating European and Japanese techniques. Decorated with original painting, gold leaf and calligraphy by the binder.

Abigail Acton

Belgium

Double hollow spine. Full boxcalf binding with inlaid moon and recessed vellum wave inlay, under- and over-dyed, gilded in white gold, and carried over to grey paper doublures. Sewn endbands.

CATHY ADELMAN

USA

French-style binding covered in fair boxcalf with matching boxcalf doublures and flyleaves. Graphite edge. Mica decoration on front board.

MARIA AICHNER

Germany

Non-adhesive binding in Perspex coloured with acrylic.

BÉATRICE ALGRIN

France

Bound in full light blue boxcalf. Front board inset with agate and onlays of contrasting colours of leather and suede. Boxcalf doublures. Titled in coloured foil.

DAVID ARROWSMITH

United Kingdom

Flush cut aluminium boards covered by dark green goatskin over three panels of natural goatskin illustrated with acrylic ink coloured wave pattern, repeated as top-edge decoration. Burnished gold leaf title.

BIRUTA AUNA

Latvia

Boards covered in turquoise blue hand-dyed calf with sculptured papier mâché waves and purple painted seaweed. Dark calf flat-back spine. Gold-tooled title on front board. Silver-waxed endpapers.

ELOÏSE BAILLE

France

Bradel binding covered in a collage of water-coloured Japanese papers with lambskin onlays. Grey Ingres endpapers, title on front board by Atelier de la Feuille d'Or.

PAMELA BARRIOS

USA

Simplified binding in full blue goatskin with beige goatskin spine. Japanese paper and thread onlays. Original paste-paper lettering. Claire Maziarczyk paper endpapers.

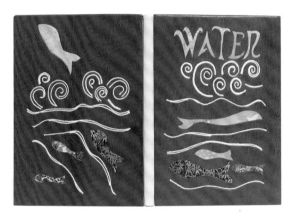

RITA BERTOLDI

Italy

Bradel binding with mixed silk spine and boards covered in coated paper painted with ink roller and spatula using printing inks, polished with graphite, engraved with pyrograph, and laminated with a polyfoil sheet made of transparent PVC. Title on front board in china enamel incorporating a teardrop inset in Paua shell.

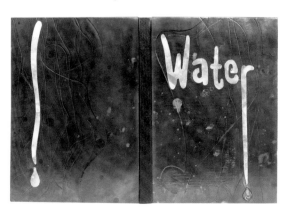

NICOLE BILLARD

Canada

Full dark turquoise chagrin leather binding. The design is made of small pieces of 'lacunose' and palladium tooling to create a splash effect. Silver 'froissé' end papers with leather joints and Lucie Lapierre marbled paper.

EVANGELIA BIZA

Greece

Four layers of transparent elastic film cut into strips and held together with silver. Exposed sewing on silver plate with linen thread. Endpapers decorated with acrylic colours.

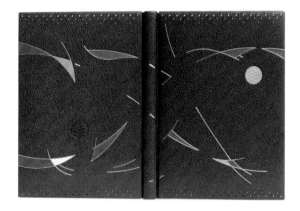

ANDREAS BORMANN

Germany

Bound in full black goatskin with blue leather onlays and gold tooling decoration on both boards. Drilled hole pattern along bottom edges. Gilt top edge. Leather endbands. Leather-jointed endpapers.

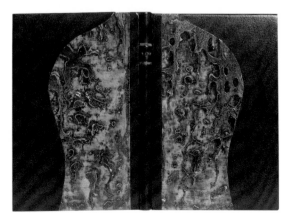

MAGDALENA BOSCH MALLEU

Spain

Binding in royal blue goatskin with encrusted artwork made of canvas, painted in oil by Fernando Rojo and representing the Mediterranean Sea. Leather doublures and suede flyleaves.

JOAN BYERS
Canada

Full dark blue goatskin binding with onlays representing the water and land masses of the area near Sidney, British Columbia. Blind-tooled lettering with gold highlights. Hydrographic nautical charts as endpapers.

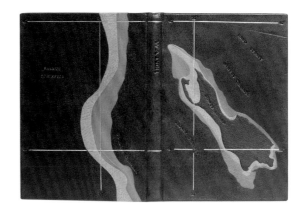

COLETTE CALMETTES
France

Bound in full hand-stained boxcalf. Tooled and lettered in coloured foils by Anne L'Or.

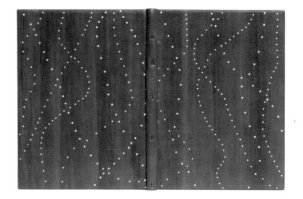

SOPHIE CHARPENTIER
France

Stub binding in grey leather with onlays of green and blue calf and mylar. Green boxcalf doublures and flyleaves.

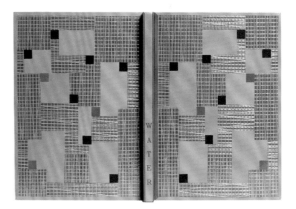

JEAN CINQ-MARS
Canada

Bound in full green goatskin with red, blue and green inlays tooled on both covers depicting waves of water that support the word 'water' in all the languages used in the book. Tooled in coloured foils. Stencil-decorated Japanese paper endpapers. The white flyleaves are also made of Japanese paper, used for umbrellas. The binding reflects the variety of languages used in the different poems.

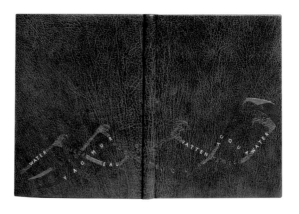

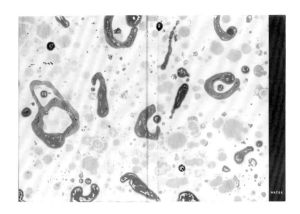

CHERYL COLE

United Kingdom

Hand-dyed full calf binding with blue calf foredge. Gold decoration to boards and spine. Soft plate offset-printed doublures and endpapers.

CECIL COLON

Belgium

Open-joint binding with spine in green Oasis goatskin and boards covered in green linen. False bands made of twisted silk ribbons attached to laced-in leather thongs, representing three little streams. The ends of these ribbons interlace the linen boards and form a wave of silky drops.

CLAUDIA CONSTANZO

Chile

Covered in full light blue goatskin with goatskin and calf onlays and blind tooling. Sewn endbands. Paper doublures and flyleaves decorated by binder.

COLEEN CURRY

USA

Full pale green buffalo leather binding with matching doublures. Raised onlays using 'lacunose' style sanded leather, and palladium tooling on covers and doublures. Title tooled in palladium. Painted and burnished top edge. Hand embroidered Japanese silk endbands. Teal suede flyleaves.

ANNETT CZAJA

Germany

Paper binding with blue goatskin trim at head and tail of spine and at corners. Cover created with white and blue tissue paper and shells. Silver and blue foil lettering.

GEORGE DAVIDSON

United Kingdom

Scarf-jointed binding in light brown, dark and light blue goatskins to give contoured, puckered and sanded surface with green onlays and other design elements suggested by the text and illustrations. Gold and palladium top edge. Multi-coloured endbands. Suminagashi endpapers by Victoria Hall.

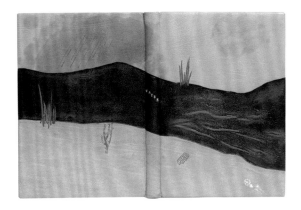

ISABELLE DE LAJUGIE

France

Simplified binding in blue chagrin. Various blue leather onlays.

MONIQUE DELAMOTTE

France

Full black calf semi-limp non-adhesive binding embroidered with silvery and metallic threads, pearls and pared leather strips. Secondary sewing of leather thongs through spine. Lettering on front board. Green straight-grain Morocco goatskin doublures and emerald green suede flyleaves.

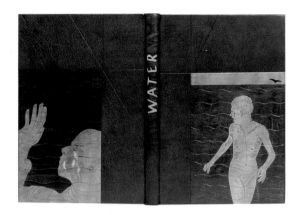

PAUL DELRUE

United Kingdom

Bound in Harmatan goatskin with four 'lacunose' panels and blind decoration of waves. Coloured endleaves. Leather joints. Sewn endbands. Title tooled in palladium on spine. Goatskin doublures and suede flyleaves.

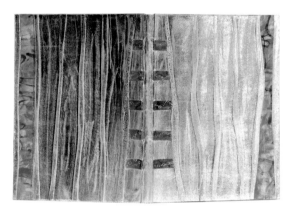

MARYSA DE VEER

United Kingdom

Limp-style binding sewn on exposed, painted linen sewing tapes. Covered in silver sanded leather with hand-painted paper strip underlays. Edges hand painted and silver stamped.

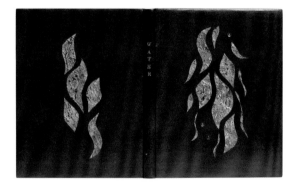

MARTINE DONATI

France

Bound in full purple goatskin with insets of pearls and paper decorated by the binder. Purple coloured wooden box with cutaway shapes revealing the decoration of the binding inside.

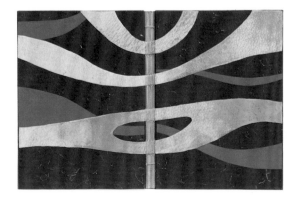

TIIA EIKHOLM

Estonia

Exposed sewing. Painted spine. Sewn on shaped leather strips running over boards. Boards covered in blue paper patterned with gold thread particles. Matching doublures.

MICHÈLE FORGET

France

Full white parchment binding with painted image and title on front board by Sandra Breard. Sewn endbands. Marbled endpapers by the binder.

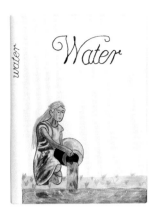

GABRIELLE FOX

USA

Green goatskin spine and double goatskin covered boards. Upper white boards cut out to reveal lower blue boards tooled in lemon gold, yellow gold and palladium. Coloured Moriki and inserts sewn in with text. Top edge coloured and gilt. Endpaper wood engraving by binder.

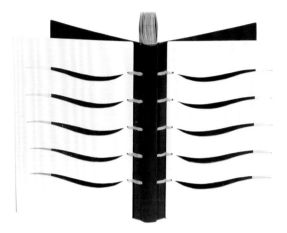

ULRIKE FRANK

Germany

Covered in grey goatskin and goat parchment. Tooled in white gold with silver foil blocking. Design represents a wet footpath with a puddle of water on a rainy day.

GUDLAUG FRIDRIKSDÓTTIR

Iceland

Covered in full vellum over raised lettering, with oil-coloured paper underlay. Leather endbands. Endpapers printed from text illustrations.

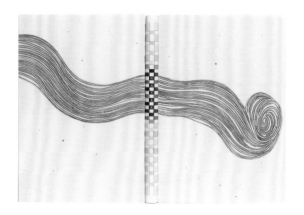

KEIKO FUJII

Japan

Simplified binding covered in white calf decorated with coloured etchings. Calf onlays and inlays. Woven title on spine consisting of nine goatskin and calf leathers. Silver endpapers with kozo washi overlays. Gold and coloured tooling.

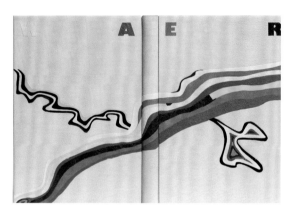

GONZAGA GIL-DELGADO FRIGINAL

Spain

Bradel binding in full pale blue buffalo skin with onlays and title in multi-coloured buffalo skin. Striped coloured edges and sewn endbands. Pale blue buffalo suede doublures and flyleaves.

TATJANA GRETSCHMANN

United Kingdom

Bound in semi-scarf-jointed full dark grey and light blue goatskin with inlays and multiple onlays and blind tooling. Distressed edge gilding. Dark grey goatskin doublures decorated with blind tooling. Hand-printed leather-jointed endpapers.

ATTILIO GROSSI

Italy

Half green goatskin binding with hand-painted silk covered boards. Glass drops applied on the silk. Grey goatskin endbands.

Jacqueline Gruszow

France

Simplified binding in black goatskin with partial glazing. Boards stamped using enamelled copper thread. Onlays of varnished and decorated magazine paper.

Karen Hanmer

USA

Bound in full blue goatskin. Blue inlays, onlays and recessed onlays in a variety of techniques. Graphite top edge. Sewn endbands. Blue goatskin doublures with white gold tooling. Blue suede flyleaves. Design based on multiple water molecules.

Karel Havlík

Czech Republic

Flat-back Bradel binding in blue straight-grained calf. Recessed oil-colour marbled paper. Burnished top edge. Sewn endbands. Titled in white foil.

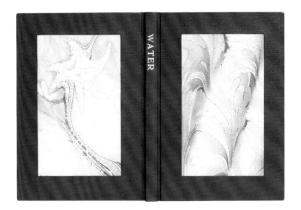

Chris Hicks

United Kingdom

Bound in blue Morocco goatskin with an onlaid abstract design in various blues and greens with gold tooling.

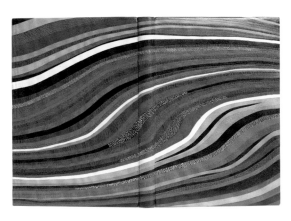

HELGA HOBDAY

Canada

Full pale green Harmatan goatskin binding with multi-coloured onlays and blind tooling. Sewn silk endbands. Doublures and flyleaves in Iwahada paper. The design was inspired by the rocky shoreline of Canada's Georgian Bay.

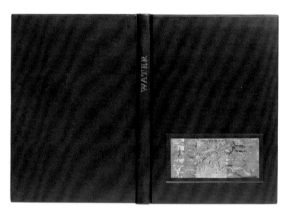

LADISLAV HODNÝ

Czech Republic

Full blue calf binding with leather inset tooled in light blue and gold. Blue suede doublures.

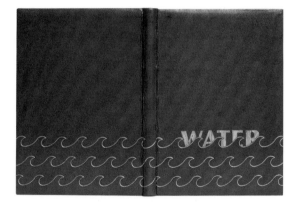

MONICA HOLTSCLAW

USA

Bound in full green goatskin with gold tooling and inlay of marbled paper and acrylic resin title on front cover. Graphite and watercolour top edge. Sewn endbands. Gold tooled blue goatskin border on inner boards with Swedish marbled paper doublures and flyleaves.

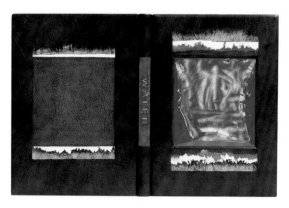

MARY HORSTSCHULZE

Germany

Binding in dark grey Oasis leather. Boards worked independently and attached later. Leather onlays and inset of acetate painted with oils. Coloured edges and leather endbands. Title tooled on onlay on spine.

PETER HOWELL

United Kingdom

Boards and doublures covered in sea blue goatskin. Onlay of contrasting colours across both boards in a single wavy line which links to the handmade paper endpapers. Title tooled on front board.

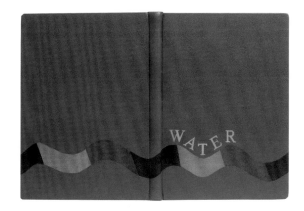

LISA ISLEY

Canada

Bound in full dark blue goatskin with gold tooling and multi-coloured inlays of snakeskin. Gold tooled title on spine. Painted top edge. Sewn endbands. Blue goatskin doublures. Machine-made marbled endpapers.

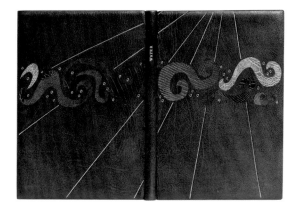

ATSUSHI ITO

Japan

Non-adhesive binding combining European and Japanese binding techniques. Covers incorporate organza and lace cloth framed in gilded wood.

YOKO ITO

Japan

Bound in pale green and white calf, scarf-jointed with calf onlays. Gold tooling and lettering. Decorated handmade endpapers.

SARAH JARRETT-KERR

United Kingdom

Covered in full blue Harmatan goatskin. Edges painted and gilt. The laminated suede flyleaves harmonise with Eric Hasse's illustration inside. Watching sunlight and moonlight on water inspired the gold tooling on the cover.

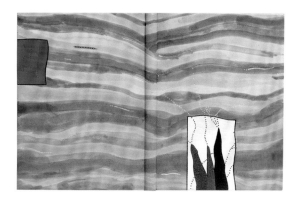

SOFIA JOHANSSON

United Kingdom

Hand-dyed, full leather binding, with inlays and onlays. Boards decorated with tooled black lines and white gold and blind tooling. Hand-painted paper doublures and hand-worked flyleaves.

JAMIE KAMPH

USA

Bound in sea-green and brown Oasis goatskin with gold-tooled panel framed in blind tooling. Gold-tooled title on spine. Inkjet-printed digital photo endpapers.

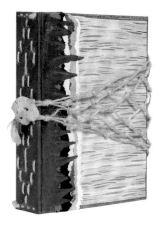

MARJE KASK

Estonia

The book has been assembled using mixed techniques. Goatskin, hemp rope, a lucky stone and recyclable materials have all been used. Front board made of waste paper and offcut leather parings.

ESTHER KIBBY

USA

Covered in deep blue Harmatan goatskin with feathered alum-tawed and multi-coloured onlays, and starfish moulded in paper clay, covered in shagreen. Top edge gilt with shell gold. French double endbands in blue, gold and white silks. Marbled endpapers by Catherine Levine.

STEFAN KREBS

Switzerland

Coffee filter paper used for covers, enhanced with a blind blocking of the title and a stylised wave. Designed to look both utilitarian and maybe a shade deceptive about its contents.

SIRJE KRIISA

Estonia

Bound in white, black and grey chrome-tanned leather. Boards shaped into wavy edges with black and yellow plastic 'drops' on top edge. Hard black concave spine binding with sections sewn onto half-tube of millboard. Painting on the roughed-up leather surface using aniline colours. Silver foil and blind tooling.

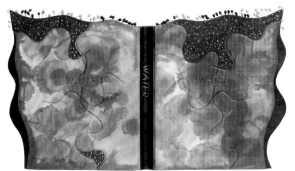

CHRISTIANE KUBIAS

Germany

Open-joint structure. Mahogany veneer over plywood boards with fretwork cutaway on front board. Sewn with fishing line through wooden spine-piece, hinged with metal rods.

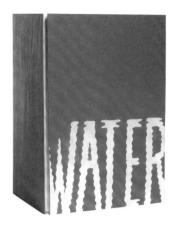

JOHN KURTZ

Belgium

Sections sewn on 'fraynot' concertina and tapes. Spine lined with Japanese paper and painted with acrylic paint. Blue textured rubber boards, protruding over spine, are decorated with rippled white lettering that fades into the distance.

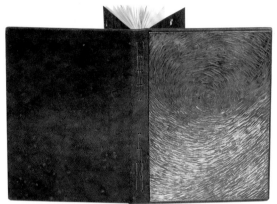

KADRI KUUSK

Estonia

Non-adhesive binding covered in grey moose leather with steel plate on front board. Secondary sewing through leather spine. Moose leather doublures and black and silver Japanese paper flyleaves. Co-maker of the forged steel: Ivar Feldmann.

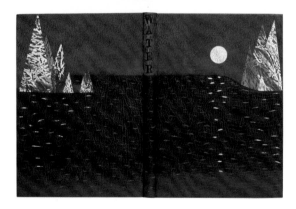

MONIQUE LALLIER

USA

Full blue goatskin binding. Part of the leather has been sanded. Gold-leaf sun and tooling. Paper onlays and flyleaves decorated by binder. Goatskin doublures.

VERONICA LAM

United Kingdom

Mixed media vellum on boards with feathered leather onlays. Title painted and then tooled in gold on the front board. Marbled endpapers.

MONICA LANGWE

Sweden

Coptic binding with wooden boards painted in various shades of blue, burnished with beeswax. Spine of each section covered in blue leather. Title on front board is made with laser technique and wood cut by hand.

ADAM LARSSON

Sweden

Full black calf binding with blind tooling. Graphite edge. Hand-painted doublures and flyleaves.

DAPHNE LERA

Australia

Boards covered in cotton printed from an original photograph of water at Middle Harbour, Sydney, Australia. Blue Oasis goatskin spine, sun-faded to blend with photograph tones. Sewn silk endbands. Endpapers also printed from an original photograph. Photographs by Anthea Boesenberg, printmaker/artist.

ANNA LINSSEN

The Netherlands

Calf spine and vellum boards with inset of cutaway overlapping shapes showing through to paste-decorated flyleaf. Gold decoration on covers and titled tooled in gold on front board.

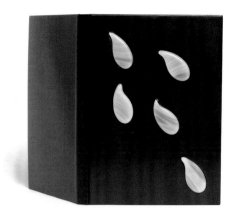

LORENA LOWE

Belgium

Simplified binding in deep blue boxcalf, onset with light blue coloured glass in the shape of water droplets. Endpapers painted in dripped, diluted pale blue acrylics.

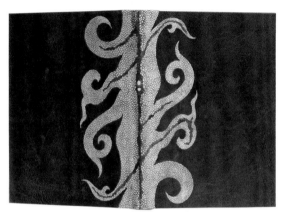

MYLYN McCOLL

United Kingdom

Case binding with hand-cut and coloured dogfish spine and hand-cut and distressed blue skiver boards. Hand-painted blue edges in wave effect. White dogfish endbands. Hand-coloured endpapers with cut-out paper onlays.

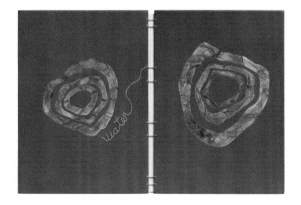

PIERRETTE McCULLOUGH

Canada

Non-adhesive binding with exposed spine sewing. Full turquoise goatskin with handmade paper onlays decorated with various inks.

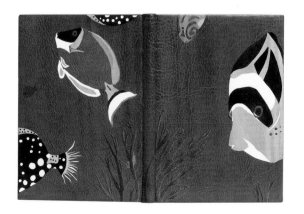

MARVEL MARING

USA

Flexible style, full blue goatskin binding, sewn on cords, with multiple leather onlays. Multi-coloured sewn endbands. Chena River marbled endpapers.

CORDULA MATTHEWS

Germany

Bradel binding with turquoise boxcalf spine. Boards covered in Japanese paper dyed with acrylic colour. Inset wire on the front board. Title tooled in silver.

GRAZIELLA MAULE

Italy

The simple purity of two glass drops inlayed into blue leather covered boards. Hand-sewn endbands.

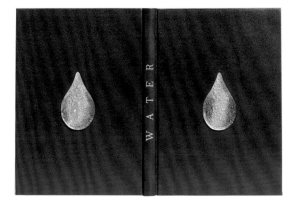

THALEIA MICHELAKI

Greece

Variation of exposed spine binding where only the tapes and the sewing can be seen. French sewing on parchment tapes. Boards covered with handmade paper dyed the colour of graphite and decorated with pieces of natural sponge. Spine covered with matching dyed paper.

YEHUDA MIKLAF

Israel

K118 structure with linen spine lining. Scarf-jointed blue, green and black goatskin. Silver foil raindrops tooled on both boards. Hand-sewn endbands. Paste-paper doublures and flyleaves.

NAOMI MITAMURA

United Kingdom

Full transparent vellum binding with woven marbled Kozo paper underlays made by binder. Silver gilt top edge. Sewn silk endbands. Full-page woodcut prints are attached by thin narrow Japanese paper strips and sewn into the texts.

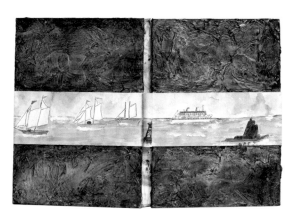

SANA MORROW

USA

Multimedia artist book. Covers built up with acrylic paint and gel medium. Watercolour sash. Acrylic endpapers. Suminagashi spine and headbands. Additions to text block include multi-media collage, letterpress excerpt from Eagle's *Aeneid* on suminagashi and, on facing page, watercolour painting on suminagashi.

OLAF NIE

Germany

Coloured vellum spine with exposed vellum tapes and piercing. Title tooled in silver. Boards made of glass tiles on cardboard.

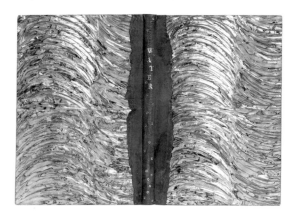

NANCY NITZBERG

USA

Textblock sewn with fishing line, then covered with an eel leather spine and shell-laminate mounted onto boards. Endpapers of dark blue luminous book-cloth; the endbands comprising the same cloth wrapped over a core. Hot-stamped title on spine and tooled bubble motif.

JOHN NOVE

USA

Case binding with embossed brown goatskin spine and digitally printed linen-covered boards. The cover image was taken at a local beach as the tide receded.

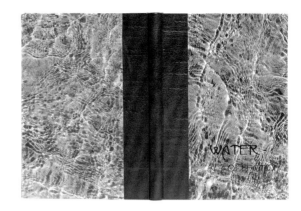

YURIKO OTSUKI

Japan

Wooden boards with green painted edges and linen spine. Paper stencils overlaying blue printed panel recessed on front and back boards.

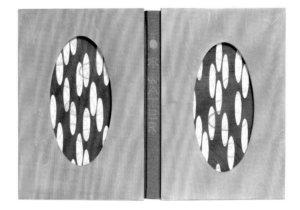

MELINDA PADGETT

USA

Bound in full black Nigerian goatskin, with green and blue goatskin inlays and onlays. Tooled in blind. Sponged top-edge decoration. Double silk endbands and hand-marbled endpapers.

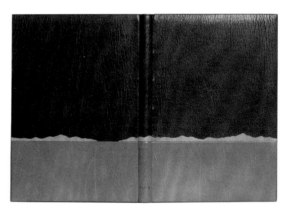

IOANNA PAPAGEORGIOU

Greece

Covered in handmade paper from Egypt. Sewn on copper tapes with copper wire. Front cover is decorated with oxidised copper leaf. Handmade Nepalese 'mineralwax' paper endpapers.

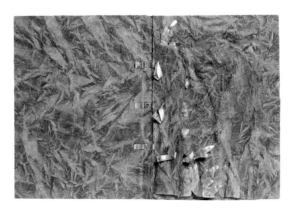

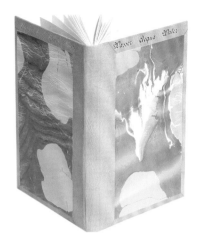

FRANCESCO PATTONO

Italy

Case binding in ochre Oasis goatskin with inset panel of hand-decorated marbled paper on boards. Matching doublures. Titling in blue foil on both boards.

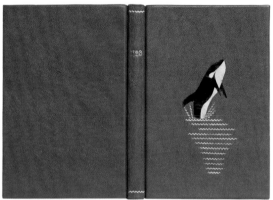

RICKY PEACOCK

United Kingdom

Full grey/blue leather library-style binding with inlay of killer whale. Hand-marbled endpapers. Silver tooling on spine and front cover.

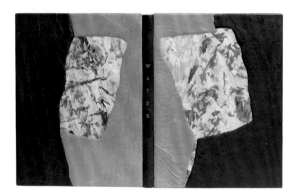

VALERIE PERESS

France

Simplified binding. Covered with grey and dark green calf over crumpled tracing paper.

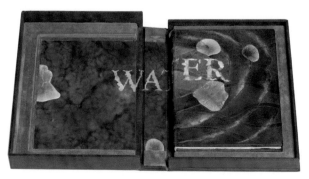

JAN PERŮTKA

Czech Republic

Full leather binding in hand-stained goatskin over sculptured boards. Raised paste-paper onlays of abstract and shell forms. Raised onlaid titling. Hand-stained endpapers.

ROZENN PILÉ

France

Full violet Oasis goatskin binding with insets of various leathers in a destructured composition overlaid with vegetable fibres.

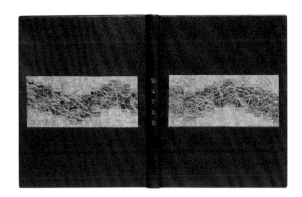

HELEN POLL

Estonia

Full red-brown leather binding with applied silver plates and water-sapphire.

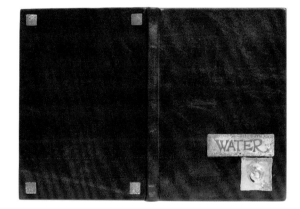

SONJA POLL

Germany

Green vellum spine and foredges. Hand-decorated paper boards and endpapers. Blocked in yellow foil. Edge decoration in dark green. Leather endbands. Cloth and paper laminated flyleaves.

MARGUERITE-MARIE PROUX

France

Stub binding with dark blue goatskin spine and decorated paper boards. Lettered in coloured foil. Blue goatskin doublures with decorated paper onlays. Japanese paper flyleaves.

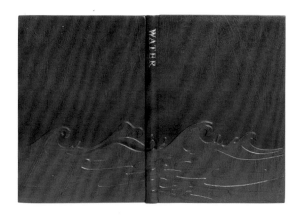

JANA PULLMAN

USA

Covered in blue goatskin over raised wave design with airbrush toning. Title hand tooled in aluminium. Top edge decorated with sprinkled patterns. Sewn two-colour silk endbands. Chiryo gami printed endpapers.

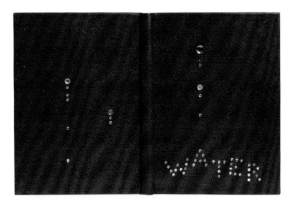

SARI RANDÉN

Finland

Covered in full red goatskin with decoration and title in cut-glass stones. Sewn endbands and marbled doublures.

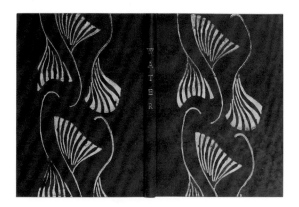

SABINE RASPER

Germany

Hand-dyed vellum binding painted with a pattern roll. Silver title. Graphite top edge. Hand-painted endpapers.

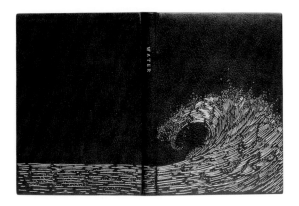

PAMELA RICHMOND

United Kingdom

Bound in navy blue goatskin with matching doublures and decorative Japanese endpapers. Tooled in white gold. Top edge gilt with white gold.

CLAUDIA RICHTER

Germany

Boards covered in yellow paper and decorated with inlaid shiny and matt white paper strips. Sections sewn on yellow dyed vellum tapes, which are drawn through slits in the vellum-covered spine and are laced through the boards.

JILL ROSE

New Zealand

Bound in New Zealand calf with front board inlaid with blue, green and red New Zealand fishskins representing the turbulent surface of the sea with the promise of treasures below, indicated by an onlaid sliver of New Zealand Paua shell. The design of the endpapers reveals the calmer waters found beneath the rough surface.

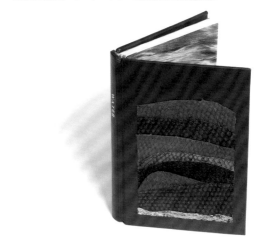

MARIA RUZAYKINA

Russia

Covered in full blue Morocco goatskin with coloured onlays and gold tooling. False raised bands and titling on spine. Top edge gilt. Sewn endbands. Marbled endpapers.

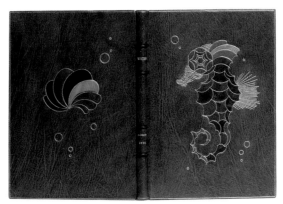

LORI SAUER

United Kingdom

Stub binding. Covered in vellum with blind impressions over pencil. Fabriano Roma endpapers. Separate folder with loose prints.

BARBARA SCHMELZER

Australia

Australian crocodile suede spine with boards covered in paper hand-decorated by binder. Silk endbands.

CLARA SCHMIDT

Germany

Non-adhesive binding covered in parchment with inset of cow stomach on front covers and doublures.

CHRISTOPHER SHAW

United Kingdom

Full dark blue Harmatan goatskin and doublures tooled in two different shades of gold leaf. Top edge gilt. Double roll endbands. J & J Jeffrey paper flyleaves.

SYLVIE SIGEL

France

Simplified binding with exposed sewing, covered in pale blue Oasis goatskin. Eelskin panels on spine. Stingray onlaid lettering. Onlays of seaweed overlaid with meerschaum. Green suede doublures and flyleaves.

Amaryllis Siniossoglou

Greece

Cloth covers. Calligraphy print inset on front board. Book bound on tapes tied in bows along spine. Suminagashi doublures.

Priscilla Spitler

USA

Covered in tan Chieftain goatskin with multi-coloured backpared goatskin onlays and gold tooling. Painted top edge and sewn endbands. Pochoir acrylic shell motifs on boards and endpapers made by the binder. Design depicts the endangered coral reefs and the melting Arctic north.

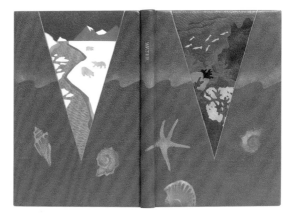

Julie Stackpole

USA

Covered in dark blue-green Niger goatskin, unevenly pared to make ocean waves, and grey Levant goatskin on the upper third, embossed with linoleum cuts in a 'rain and clouds' design. Onlays of other leathers on the lower parts of the covers, also lino-embossed. Titled in blind, and blind tooling on the spine. Coloured top edge and sewn silk endbands. 'Raindrops' marbled paper endpapers made by binder.

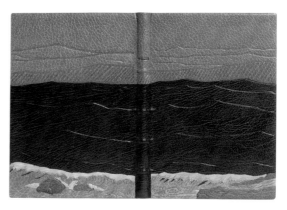

Naima Suude

Estonia

Case binding in vegetable-tanned leather, further decorated with acrylic and aniline paint. Sewn endbands and painted edges.

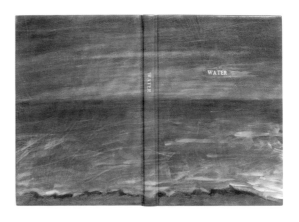

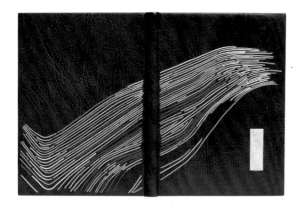

BARBARA TERZOPOULOS

Greece

Binding in full dark blue Harmatan goatskin. Decoration is applied in thin blue, green and grey leather strips set into leather and silver tooling. Titling in silver on front board. Sewn silk endbands. French marbled paper doublures.

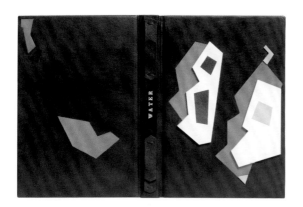

TULVI-HANNELI TURO

Estonia

Non-adhesive full blue calf binding, angular shaped white raised onlays, leather inlays, and silver foil tooling. Hand-marbled endpapers. Sections bound on a round shaped piece of leather forming a flange. Everything flows, even ice, although it is temporarily solid.

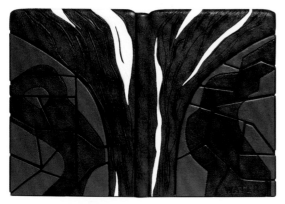

JACEK TYLKOWSKI

Poland

Covered in blue and black goatskin over balsa-wood relief boards. Sculptured raised goatskin onlays hand-painted with white acrylic. Blind tooling and lettering. Leather doublures and suede flyleaves.

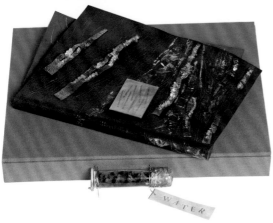

EVANGELIA TZANETATOU

Greece

Limp structure in dark blue leather with paste-paper endpapers. Crystal beaded endbands and paste decorated book edges. Covers decorated with iridescent, wavy effects, beads and a panel displaying sea-sky and lyrics of a traditional, sailor's love song.

Aušra Vaitiekūnaitė

Lithuania

Full parchment binding with partly exposed vellum tapes painted and stained. Title painted on tapes on front cover and again on exposed ends of tapes at foredges. Sewn endbands.

Gerritt VanDewerker

USA

Bradel binding covered in blue-green striped cotton cloth with multi-coloured mammal and reptile skin onlays. Graphite top edge and sewn endbands of blue and silver silk. Title stamped in silver foil on spine. Japanese indigo Taiten paper endpapers.

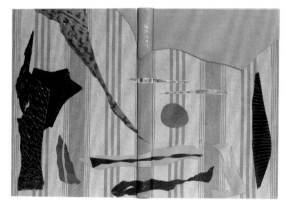

Peter Verheyen

USA

Case binding covered in paste-paper made by binder with leather strips at foredges, and top and bottom of spine. Title stamped in graphite on spine. Coloured top edge. Grey and blue sewn endbands.

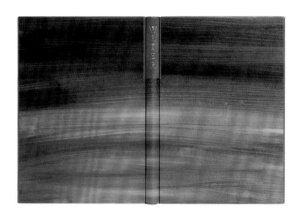

Estela Vilela

Brazil

Bound with Perspex boards attached to Japanese paper spine with secondary sewing. Monotype-printed endpapers.

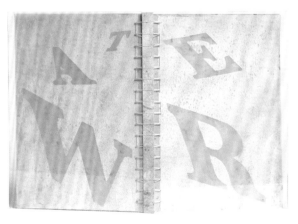

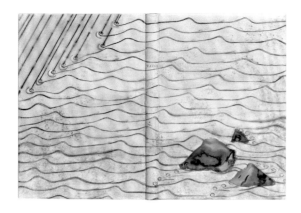

GENEVIÈVE VON HAHN

Germany

Bound in alum-tawed goatskin painted with watercolour. Ink and gold tooling. Inlays of stone on the front board.

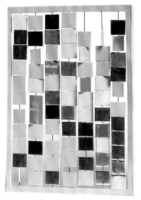
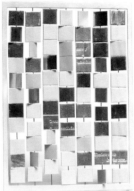

VASSILIKI VLACHOU

Greece

Bound in white goatskin. Little squares made from light blue and silver paper mounted on silver wires which turn, giving a kinetic effect. Titling on the movable squares.

FRIEDERIKE VON HELLERMANN

Germany

Open-joint structure with exposed sewing. The bookblock is sewn onto dark blue dyed vellum strips attached to plates of white enamel with screen-printed blue stripes. Hand-dyed dark blue endpapers.

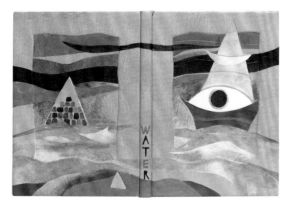

IVANA VYHNALOVÁ

Czech Republic

Bound in tan goatskin with goatskin and coloured parchment onlays. Leather cut-out titling on spine. Double leather endbands. Handmade paper doublures.

ULRICH WIDMANN

Germany

Full leather binding in light blue goatskin with abstract decoration using coloured foils. Coloured top edge. Leather endbands.

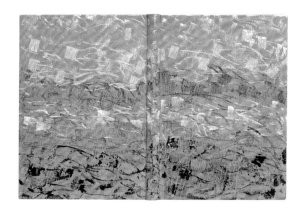

KAROL WILCZYNSKA

New Zealand

Covered in scarf-jointed cream, mid- and dark blue New Zealand wild brushtail possum skin, dyed to match title-page illustration, and to suggest ocean swell. Dark blue and white endbands. Materials unique to New Zealand, a country surrounded by water, in which the seas are a large part of everyone's life. Leather contains scraps and scars of the wild, as the possum is not usually used for bookbinding.

FLORIAN WOLPER

Switzerland

Covered in full blue goatskin and tooled in silver and blind. Gilt top edge. Sewn silk endbands. Airbrushed paper doublures and flyleaves. Title on doublure.

ANNA YEVTUKH

United Kingdom

Bound in full light goatskin with padded round shapes of various blue calf on the front board with title tooled in blind. Two-colour sewn endbands. Handmade marbled endpapers.

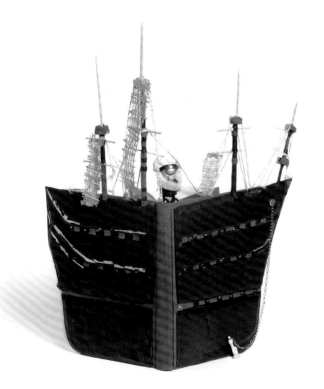

Žanna Žuravel

Estonia

Book object made of leather, paper, thread, wood, and detachable plastic figure. Silver tooling. Marbled endpapers with overlaid cut-out pieces.

Glossary of
bookbinding terms

BLIND TOOLING Decoration produced on the surface of covering materials by hot tools without the use of gold or coloured foils.

BLOCKING Decoration or lettering applied by means of a blocking machine rather than by hand pressure.

BOOKBLOCK Trade term for the paper contents of the book, as distinct from the outside cover.

BOX BINDING Protective walls added to the boards at head, tail and foredge, usually meeting halfway along the centre of text block edges.

BRADEL A case binding in which the boards are attached to the spine stiffener before covering.

CHAGRIN Goatskin or sheepskin with a tight regular grain.

CUSHIONED BOARDS Formed by trimming and glass-papering the edges of the underlying millboard. It has a pleasing aesthetic and tactile effect.

DECKLES The uneven edges of handmade paper which result from the pulp seeping between the edges of the mould and the deckle which contains the pulp during the formation of the sheet.

DOUBLURES The covering, usually with leather, of the inner surfaces of the boards. In most cases they extend to all four edges.

EDGE DECORATION The treating of the edges of the pages (the bookblock) with colour, patterns or gilding.

ENDBANDS Also called headbands. Extensions of each end of the text block. A decorative band, usually of coloured silks or cotton thread, worked over a core of leather and vellum top and bottom of the spine.

ENDPAPERS The first and last leaves of the bookblock, often made from coloured or patterned paper.

FEATHERED GOATSKIN Effect produced by paring the leather very thin so that a ragged edge results. The deeper the grain, the easier it is to achieve the feathering.

FINISHING Titling and decorating book covers.

FOREDGE The front edge of the book.

FORWARDING The binding of a book up to the finishing stage.

FRENCH GROOVE The depression between the back edge of the board and the shoulder of the spine. One purpose of this is to enable the use of thicker leather than would otherwise be possible.

FULL BINDING A binding covered in a single material, normally cloth or leather.

GOLD TOOLING The process of lettering or decorating a binding with heated tools and gold leaf.

HEAD The top edge of the book.

INLAID Effect whereby leather or other materials are set into the covering material by cutting out and removing a shape and fitting in the new piece to make part of the design.

K118 BINDING Structure discovered in a book of 1493 by American conservator Bruce Levy, while working at the Harry Ransom collection in Texas. It is rounded but not backed, and the boards are bevelled to match the rounding. It has vellum or linen spine lining cut into tabs which extend onto and are adhered alternately to the outside and inside of the boards, which are flat on the inside at the spine edge but chamfered and rounded on the outside. The binding opens as much as 360 degrees but will always return to its rounded shape without going concave.

LACUNOSE A decorative technique where scraps of leather are pared very thin and glued with PVA to a Japanese tissue paper, then consolidated with a wash of watery PVA. Once dried, all the ridges are sanded off the leather collage. Further layers can be added.

LEATHER Most commonly goatskin and calfskin. Sheepskin, pigskin and a variety of other animal and fish skins can also be used.

MARBLED PAPER Paper which has been sponged with alum water is laid on the surface of a size on which colours float. The colours are lifted off with the paper, and are fixed to it by the mordant action of the alum. Ox-gall in the colours enables them to expand and stay on the surface of the size. The patterns can be lifted off only once, so every marbled sheet is unique.

MEETING GUARDS A guard to which the section is sewn, folded back on itself.

MILLBOARD Best quality dense fibre bookbinding board, available in a range of thicknesses.

MILLIMETRE BINDING A variation of the Bradel binding with added leather or vellum trim on the boards.

ONLAID Effect whereby leather, paper or other materials, pared extremely thin, are adhered to the top of the covering leather to make part of the design.

ONSET An object or found item attached to the surface of the binding.

OPEN-JOINT STRUCTURE Spine and boards are covered separately; the textblock is sewn onto vellum and leather laminated tabs which are then attached directly to the top of the boards, thus leaving the spine joint area uncovered.

NON-ADHESIVE BINDING A book without paste or glue, relying on sewing structure for flexibility in opening.

PARCHMENT Sheepskin treated in the same way as vellum.

PASTE An adhesive made from flour and water.

PASTE PAPER The surface of the paper is coated with coloured paste and then, while it is still wet, dabbed or drawn on with various implements to form patterns.

PUCKERING This is formed during the covering process when the wet leather is squeezed and condensed to form ridges and folds as part of the eventual design.

PVA (polyvinyl acetate) A flexible quick-drying adhesive.

RUBOW BINDING A variation of the Bradel binding with leather trim all along the head and tail (named after the librarian who suggested it).

SCARF-JOINTED Overlapping and adhered bevels on the edges of two pieces of leather, resulting in a level surface.

SCULPTURED BOARDS Boards which have been laminated with two or more thin layers, areas of which have been removed, or, conversely, areas built up with other materials, to form part of a design.

SECTIONS (OR SIGNATURES) A set of folded sheets of paper as prepared for sewing.

SHAGREEN Commonly made from skins of sharks and stingrays.

SIMPLIFIED BINDING A construction with a rounded, not backed, spine. The boards are bevelled from underneath along the spine edge and attached with adhesive to linen joints and leather from the spine covering.

SPINE The back edge of the book (the part visible when a book is placed on the shelf).

SQUARES The amount that the boards overlap the bookblock at the head, tail and foredge, thus protecting the edges of the paper.

STUB BINDING Narrow folded strips of paper are sewn onto the sections to prevent contact of adhesive to the textblock.

SUEDE Leather which has had the flesh side prepared with a nap finish.

TAIL The bottom edge of a book.

VELLUM Usually calf- or goatskin which, after initial soaking in a lime solution, is scraped to remove wool and flesh. It is then stretched on a frame and has its grease removed by application of a cream of whiting, soda and water. When dry, it is shaved with a special knife to achieve uniformity of thickness.

Index of entrants

KURTZ, JOHN (p. 66)
Avenue Ernestine 2, 1050 Ixelles. **T** +32 2 646 17 36. **E** jkurtz@doctors.org.uk

LOWE, LORENA (p. 68)
Avenue de la Poule d'Eau 7, 1970 Wezembeek-Oppem. **T** +32 2 688 4701.
E lorena_lowe@hotmail.com

VAN CAMP, TOON (p. 47)
Diercxsensstraat 39, 2018 Antwerp. **T** +32 3 237 46 68.
E toonvancamp@hotmail.com

VAN MECHELEN, JULIA (p. 48)
Heilige Geeststraat 7, 3290 Diest. **T** +32 13 33 67 84. **E** j.j.camps1@pandora.be

BRAZIL

VILELA, ESTELA (p. 79)
Rua Rodésia 94, Apto 24, 05435–020 São Paulo. **T** +55 11 38156623.
E estelavilela@terra.com.br

CANADA

BENOÎT-ROY, SIMONE (p. 23)
3555 Berri Street # 1709, Montreal, H2L 4G4, Quebec. **T** +1 514 848 9432.
E sbroy2@videotron.ca

BILLARD, NICOLE (p. 54)
335 Victor Hugo Brossard J4W 1T4, Quebec. **T** +1 450 672 1035.
E nbillard@videotron.ca

BYERS, JOAN (p. 55)
10780 West Saanich Road, North Saanich, V8L 5P8, British Columbia.
T +1 250 656–7376. **E** kelpie@shaw.ca

CINQ-MARS, JEAN (p. 55)
5304 de Bordeaux, Montreal, H2H 2A7, Quebec. **T** +1 514 528 6157.
E cinqmarsj@videotron.ca

HOBDAY, HELGA (p. 62)
30 Muir Park Circle, Senneville, H9X 1T8, Quebec. **T** +1 514 457 9645.
E jhobday@sympatico.ca

ISLEY, LISA (p. 63)
7435 Springbank Way SW, Calgary, T3H 4V4, Alberta. **T** +1 403 242 2536.
E l.isley@shaw.ca

McCULLOUGH, PIERRETTE (p. 68), 962 Boissy, Saint Lambert, J4R 1K4, Quebec.
T +1 450 671–8034. **E** pierrette-robert@sympatico.ca

SKINNER, DAWN (p. 45)
3229 2 Street S.W. Calgary, T2S 1T5, Alberta. **T** +1 403 266 1759.
E dawn.skinner@telus.net

WU, ROBERT (p. 49)
55 Homewood Avenue, Toronto, M4Y 2K1, Ontario. **T** +1 416 927 1367.
E robert@studiorobertwu.com

CHILE

CONSTANZO, CLAUDIA (p. 56)
Marco Polo 1111, Depto. 123, Las Condes, 7550479 Santiago. **T** +56 2 7614512.
E claudia@constanzo.cl

PEOPLE'S REPUBLIC OF CHINA

RUI MIN (p. 38)
FG Buch Kunst, Hochschule für Kunst und Design Halle, Seebener Strasse 1, 06114
Halle-Saale, Germany. **T** +49 1799417325. **E** minrui73@hotmail.com

CZECH REPUBLIC

Čabalová-Hlaváčová, Eliška (p. 25)
 Jubilejní 14, 70030 Ostrava-Hrabůvka. E cabalova@post.cz
Havlík, Karel (p. 61)
 Nádražni 617, 26210 Mnisek pod Brdy. T +420 602 107 285.
Hodnÿ, Ladislav (p. 62)
Perůtka, Jan (p. 72)
 K Luhám 197, 76302 Zlín-Louky T +420 604 238 559. E perutka.UKV@seznam.cz
Sobota, Jan (p. 45)
 Sklenarska 5, 35733 Loket. T +420 352–685 130. E jan@jsobota.cz
Vyhnalová, Ivana (p. 80)
 Palackého 7, 33441 Dobřany. T +420 777 034221. E vyhnalova.i@seznam.cz

DENMARK

Jørgensen, Mette Humle (p. 34)

ESTONIA

Eikholm, Tiia (p. 58)
 Akadeemia Tee 6–53, 12611 Tallinn. E tiia@pictury.org
Grünbach-Sein, Külli (p. 11)
 Turu Plats 5/7–44, 11611 Tallinn. T +372 5269933. E kgs@hot.ee
Haljasmäe, Rene (p. 31)
 Linnamäe Tee 1–16, 13921 Tallinn. T +372 6659443. E binder@hot.ee
Kask, Marje (p. 64)
 Leegi 4, 10919 Tallinn. T +372 6724612.
Kriisa, Sirje (p. 65)
 Allika Tee 2–54, 76607 Keila. T +372 5234400. E sirje.kriisa@scriptamanent.ee
Kuusk, Kadri (p. 66)
Lukats, Kaia (p. 15)
 Jaama 12–6, 51009 Tartu. T +372 56564660. E kaia.lukats@art.tartu.ee
Maantoa, Rutt (p. 36)
 Mõisavahe 7–13, 50707 Tartu. T +372 55572499. E ruttm@art.tartu.ee
Mänd, Lennart (p. 37)
 Sakala 9–4, 10141 Tallinn. T +372 5207344. E lennart@artun.ee
Olt, Kaire (p. 41)
 Kivila 42–101, 13918 Tallinn. E olt@hot.ee
Piisang, Tiina (p. 43)
 Vilu Tee 16, 11912 Tallinn. T +372 6 232 516. E piisangt@hot.ee
Poll, Helen (p. 73)
 Tallinna Mnt 68, 90510 Haapsalu. T +372 51 74 828. E helenp@colleduc.ee
Rannamets, Jane (p. 43)
 Uuesauna Tee 11, 74019 Viimsi Vald. T +372 51 82385. E jane.rannamets@mail.ee
Summatavet, Ella (p. 46)
 Ranniku Tee 29–4, 12113 Tallinn. T +372 6232 000. E ellasummat@hot.ee
Suude, Naima (p. 77)
 Läänemere 3–91, 13913 Tallinn. T +372 55536021.
Turo, Tulvi-Hanneli (p. 78)
 Maneezi 6–5, 10117 Tallinn. T +372 56201751. E tulvi.turo@kanut.ee
Vijar, Tiiu (p. 48)
Žuravel, Žanna (p. 82)
 Katleri 13–44, 13915 Tallinn. T +372 58100204. E zannazuravel581@gmail.com

FINLAND

RANDÉN, SARI (p. 74)

Everstinkuja 1B 29, 02600 Espoo. **T** +358 9541 7272. **E** sari.randen@fonet.fi

FRANCE

ALGRIN, BÉATRICE (p. 52)

39 avenue de Saint Cloud, 78000 Versailles. **T** +33 1 39 25 09 98.
E listel@reliure.net

BAILLE, ELOÏSE (p. 53)

16 rue Paul Albert, 75018 Paris. **T** +33 1 42 51 33 89. **E** contact@eloisebaille.com

BANSARD, MARGOT (p. 22)

1 bis rue de la Pépinière, 54200 Toul. **E** ma_buddha_affaire@hotmail.com

BOIGE, ANNIE (p. 7)

456 rue de Poissy, 78670 Villennes-sur-Seine. Tel: +33 1 39 75 41 88.
E annie.boige@wanadoo.fr

CALMETTES, COLETTE (p. 55)

10 chemin des Roselières, 26100 Romans-sur-Isère. **T** +33 4 75 47 80 63.
E cjf.calmettes@free.fr

CHARPENTIER, SOPHIE (p. 55)

5 Villa Chaptal, 92300 Levallois-Perret. **T** +33 1 47 57 56 01.
E dinocharpentier@yahoo.fr

COLL, EMMA (p. 26)

7 place du Champ Clos, 22100 Dinan. **T** +33 2 96 85 16 84. **E** emma.coll@wanadoo.fr

COURCHAY, ANNE-LISE (p. 9)

Atelier no. 7, 13 rue Henri-Schmitt, 93100 Montreuil. **T** +33 673 038070.
E annelisecourchay@orange.fr

DE LAJUGIE, ISABELLE (p. 57)

8 rue Raynouard, 75016 Paris. **T** +33 6 74 53 50 61.
E isabelledelajugie@hotmail.com

DELAMOTTE, MONIQUE (p. 57)

11 avenue de Lattre de Tassigny, 92100 Boulogne-Billancourt. **T** +33 1 46 03 01 92.
E alfa.petitemaison@wanadoo.fr

DELPRAT, HÉLÈNE (p. 27)

'La Ferme des Vences', 1088 chemin des Vences, 13122 Ventabren.
T +33 4 42 92 67 38. **E** atelier.delprat@gmail.com

DONATI, MARTINE (p. 58)

24 rue des Monforts, 77810 Thomery. **T** +33 1 77 03 00 55. **E** martdonati@aol.com

DUMONT, DOMINIQUE (p. 9)

13 rue Baudin, 93100 Montreuil. **T** +33 1 48 57 08 96. **E** habillerlelivre@wanadoo.fr

DURAND, MARTINE (p. 28)

123 rue de Longchamp. 75116 Paris. **T** +33 1 45 53 70 63. **E** mmmdurand@aol.com

ELBEL, BENJAMIN (p. 10)

E benjamin.elbel@gmail.com

FAURE, ISABELLE (p. 29)

13 rue Baudin, 93100 Montreuil. **T** +33 1 48 57 08 96. **E** habillerlelivre@wanadoo.fr

FORGET, MICHÈLE (p. 59)

3 rue Hélène Boucher, 91600 Savigny-sur-Orge. **T** +33 1 69 24 79 52.

GIARD, CHRISTINE (p. 30)

52 avenue des Acacias, 59700 Marcq en Baroeuil. **T** +33 6 12 28 14 84.
E aubecq-giard@neuf.fr

GIORDAN, ANNE (p. 31)

35 route de Paris, 67117 Ittenheim. **T** +33 388 64 48 75. **E** giordan.anne@wanadoo.fr

GRUSZOW, JACQUELINE (p. 61)
 11 allée des Bourgognes, 60500 Chantilly. **T** +33 3 44 57 11 19.
 E jacqueline.gruszow@wanadoo.fr
MONTANIÉ, ANNE (p. 38)
 46 avenue Charles Floquet, 75007 Paris. **T** +33 1 40 61 02 96. **E** bmtn@wanadoo.fr
NOURAÏ, MICHÈLE (p. 40)
 4 rue Alfred Bruneau, 75016 Paris. **T** +33 1 45 27 34 14.
 E michele.nourai@wanadoo.fr
PAPADOPOULOS, ADDA (p. 42)
 5 rue de la Tour, 92190 Meudon. **T** +33 46 26 06 22. **E** addapapadopoulos@orange.fr
PERESS, VALERIE (p. 72)
PILÉ, ROZENN (p. 73)
 2 rue Victorien Sardou, 75016 Paris. **T** +33 1 42247819. **E** rozenn.pile@noos.fr
PROUX, MARGUERITE-MARIE (p. 73)
 8 rue Angelique Verieu, 92200 Neuilly/Seine. **T** +33 1 46 24 57 37.
SIGEL, SYLVIE (p. 76)
 185 boulevard Murat, 75016 Paris. **T** +33 1 42 88 34 58. **E** sylvie.sigel@free.fr
TARAL, ALAIN (pp. 2–3)
 236 impasse de la Bergeronette, 83210 La Farlede. **T** +33 4 94 48 76 98.
 E a.taral@wanadoo.fr

GERMANY

AICHNER, MARIA (p. 52)
 Tainger Strasse 19, 85669 Zeilern. **T** +49 8124 8949. **E** jos-zeilern@gmx.de
BORMANN, ANDREAS (p. 54)
 Greifenhagener Strasse 62, 10437 Berlin. **T** +49 30 4499003. **E** bormanna@state.gov
CZAJA, ANNETT (p. 57)
 c/o Buchbinderei Simon Prey, Wilmersdorfer Strasse 60/61, 10627 Berlin.
 T +49 30 323 4064. **E** annettcz@gmx.de
DETTLAFF, CLAUDIA (p. 27)
 Sommerlindenstrasse 4, 04319 Leipzig. **T** +49 341 6514658.
 E info@buchbinderei-dettlaff.de
FRANK, ULRIKE (p. 59)
HAVEKOST, ANNETTE (p. 32)
 Königsteiner Strasse 13, 01824 Rosenthal. **T** +49 35033 76883. **E** nettegelb@yahoo.de
HORSTSCHULZE, MARY (p. 62)
 Hauptstrasse 38, 79379 Müllheim. **T** +49 7631 937318. **E** mary.horstschulze@web.de
HÜBOTTER, LORE (p. 12)
HUNOLD, FREYA (p. 33)
KADEN, JANA (p. 13)
 Uhlandstrasse 7, 06114 Halle/Saale. **E** jana.kaden@gmx.de
KLOSE, JENNIFER (p. 35)
KRANZ, IREEN (p. 14)
 E info@ireenkranz.de
KUBIAS, CHRISTIANE (p. 65)
 Fraunhoferstrasse 42, 84453 Mühldorf. **E** chkubias@web.de
LASS, RITA (p. 14)
 Robert-Blum-Strasse 7, 06114 Halle/Saale. **T** +49 176 23161735. **E** ritalass@gmx.de
LOBISCH, MECHTHILD (p. 15)
MATTHEWS, CORDULA (p. 69)
 Blumenhof 6, 53840 Troisdorf. **T** +49 2241 1265431. **E** c.matthews@freenet.de

NATTERER, SUSANNE (p. 39)
Hildastrasse 29, 79102 Freiburg. **T** +49 761 73058. **E** s_natterer@web.de
NIE, OLAF (p. 70)
Pfarrgasse 1, 82266 Inning a.A. **T** +49 8143 6359. **E** habubi.nie@t-online.de
ODAMETEY, ANDREA (p. 17)
OELMANN, MANFRED (p. 41)
Marthastrasse 5, 38102 Braunschweig. **T** +49 531 73826.
E manfred.oelmann@t-online.de
POLL, SONJA (p. 73)
Schülinstrasse 20, 89073 Ulm. **T** +49 731 1766808. **E** sonja.poll@web.de
PULS, ANNE (p. 43)
Schiblirainweg 11, 8636 Wald, ZH, Switzerland. **E** pulsanne@web.de.
RASPER, SABINE (p. 74)
Atelierhof Scholen 53, 27251 Scholen. **T** +49 4245 267. **E** sabine.rasper@scholen53.de
RICHTER, CLAUDIA (p. 75)
Georg-Cantor-Strasse 4, 06108 Halle/Saale. **T** +49 345 3881614.
E buchkunst-claudiarichter@web.de
SCHMIDT, CLARA (p. 76)
Triebelsstrasse 10, 52066 Aachen. **E** claraschmidt@gmx.de
SCHNEIDER, ELISABETH (p. 44)
Gerhart-Hauptmann-Strasse 3, 67346 Speyer. **T** +49 6232 962309.
E m.elisa.schneider@web.de
SCHNEIDER, JONAS (p. 45)
Händelstrasse 33, 06114 Halle/Saale. **E** derjone@gmx.net
SIEBER, CHRISTINE (p. 19)
Eilersweg 35, 22143 Hamburg. **T** +49 40 6772213. **E** christine.sieber@web.de
VON HAHN, GENEVIÈVE (p. 80)
Holbeinstrasse 18, 60596 Frankfurt. **T** +49 69 61 86 92. **E** gvonhahn@web.de
VON HELLERMANN, FRIEDERIKE (p. 80)
Puschkinstrasse 28, 06108 Halle/Saale. **T** +49 176 23975054. **E** rikeline@gmx.net
WALKER, JULIANA (p. 50)
E walker.juliana@web.de
WIDMANN, ULRICH (p. 81)
Schauinslandstrasse 118, 79100 Freiburg. **T** +49 761 2909926. **E** bookdesign@gmx.de
WÜNSCHE, THERESA (p. 19)
Am Grüngürtel 3, 01277 Dresden. **T** +49 351 2512350. **E** n8wache@web.de
YEROSHENKOVA, KATERYNA (p. 50)
E yeroshenkova@gmx.de

GREECE

BIZA, EVANGELIA (p. 54)
81–83 Kallidromiou Street, 10683 Athens. **T** +30 210 8254800.
E evabiza@hotmail.com
MICHELAKI, THALEIA (p. 69)
31 Z. Pigis Street, 10681 Athens. **T** +30 210 3825564.
E thaleia_michelaki@mycosmos.gr
PAPAGEORGIOU, IOANNA (p. 71)
31 Filotimou Street, 11363 Athens. **T** +30 210 8819815.
E geor2000gr@yahoo.com
PARLAVANTZA-TSITOURA, EVANGELIA (p. 42)
30 Monemvassias Street, Maroussi 15125 Athens. **T** +30 210 6848974.
E tsitourae@ath.forthnet.gr

Siniossoglou, Amaryllis (p. 77)

 Kaireios Library, 84500 Hora Andros. **T** +30 22820 22262. **E** ama_s@hotmail.com

Terzopoulos, Barbara (p. 78)

 Rodon 15, 14578 Ekali. **T** +30 210–8132–138. **E** b_terzopoulos@hotmail.com

Tzanetatou, Evangelia (p. 78)

 163 Tritis Septemvriou Street, 11251 Athens. **T** +30 210 8670131.
 E etzanet@otenet.gr

Vlachou, Vassiliki (p. 80)

 Kallidromiou 81–83, 10683 Athens. **T** +30 210 8254800.
 E 6974219178@mycosmos.gr

ICELAND

Einarsson, Ragnar Gylfi (p. 29)

 Grenibyggd 21, 270 Mosfellsbaer. **T** +354 863 8835. **E** boklist@simnet.is

Fridriksdóttir, Gudlaug (p. 59)

 Grenibyggd 21, 270 Mosfellsbaer. **T** +354 845 7835. **E** boklist@simnet.is

ISRAEL

Agassi, Ido (p. 21)

 PO Box 467, 40691 Herut. **T** +972 544570877. **E** agassim@netvision.net.il.

Miklaf, Yehuda (p. 69)

 PO Box 10536, 91104 Jerusalem. **T** +972 2 679 2015. **E** fritzmiklaf@bezeqint.net

ITALY

Balbiano d'Aramengo, Cristina (p. 21)

 Via Angelo Del Bon 1, 20158 Milan. **T** +39 02 3760058. **E** cristina@professionelibro.it

Bertoldi, Rita (p. 53)

 Via dei Ferrabò 16, 26100 Cremona. **T** +39 335 697 4274.
 E lanuovarapida@interfree.it

Fagnola, Paola (p. 29)

 Via Mercanti 9A, 10122 Turin. **T** +39 011 544 266. **E** paola.fagnola@gmail.com

Giannini, Lapo (p. 30)

 Via E. Berlinguer 4, Poggio alla Croce, Incisa Val d'Arno, 50064 Florence.
 T +39 55–8337902. **E** lapo.giannini@libero.it

Grossi, Attilio (p. 60)

 Via Venalzio 13, 10146 Turin. **T** +39 11 743818. **E** attilio.grossi@libero.it

Maffei, Bruna (p. 16)

 Filadelfia 152, 10137 Turin. **T** +39 11 3141439. **E** Armando.tinti@alice.it

Maule, Graziella (p. 69)

Pattono, Francesco (p. 72)

 Via Michele Coppino 65, 10147 Turin. **T** +39 11218686.

JAPAN

Abe, Miyuki (p. 51)

Fujii, Keiko (p. 60)

 2–2–11–2012, Tsukuda, Chuo-ku, 104–0051 Tokyo. **E** reliure@coral.ocn.ne.jp

Ito, Atsushi (p. 63)

 Studio Livre, 1–37 Kandajimbocho, Chiyoda-ku, 101–0051 Tokyo.
 T +81 3 3295 6244.

Ito, Yoko (p. 63)

 1–10–1–1307, Shibaura, Minato-ku, 105–0023 Tokyo. **T** +81 3 3452 6233.
 E yoko56@excite.co.jp

NAKAJIMA, IKUKO (p. 39)
 301, 3–19–5 Kamisyakujii, Nerima-ku, 177–0044 Tokyo. **T** +81 3 3594 1967.
 E ikukon@themis.ocn.ne.jp
NAKAO, EIKO (p. 39)
 3–12–19–501, Tenma, Kitaku, 530–0043 Osaka. **T** +81 6 6351 4887.
 E nakao-d@f4.dion.ne.jp
NISHIO, AYA (p. 40)
OHIRA, RITSUKO (p. 17)
OTSUKI, YURIKO (p. 71)
SAKAI, ERI (p. 44)
TAIRA, MADOKA (p. 46)
 344–12–502, Uchikoshi-machi, Hachioji, 192–0911 Tokyo. **T** +81 42–642–4732.
 E VFE11762@nifty.com
UCHIDA, YUKIKO (p. 47)
 1–1–11–512, Minami-Ikebukuro, Toshima-ku, 171–0022 Tokyo.
 T +81 3 6804 1821. **E** slowboat@kta.biglobe.ne.jp
UENO, YOKO (p. 47)
 3–29–27–208, Kumegawa-cho, Higashimurayama-shi, 189–0003 Tokyo.
 T +81 42–397–8341. **E** yoko@sec.email.ne.jp

LATVIA

AUNA, BIRUTA (p. 53)
 Kr. Barona 37–7, 1011 Riga. **T** +371 67311667. **E** birutaf@inbox.lv

LITHUANIA

VAITIEKŪNAITĖ, AŪSRA (p. 79)
 Vokieču 15–17, 01130 Vilnius. **T** +370 688 33569. **E** vaiaus@gmail.com

THE NETHERLANDS

LINSSEN, ANNA (p. 67)
 Begijnenhofstraat 22, 6131EX Sittard. **T** +31 464580048.
VAN LIESHOUT, BERDIEN (p. 48)
 Sluisstraat 126, 5666AN Geldrop. **T** +31 402 854522.
 E berdien.vanlieshout@chello.nl
WILGENKAMP, MARJA (p. 20)
 Binnenplaats 40, 1695JJ Blokker. **T** +31 229 236658. **E** marjawilgenkamp@planet.nl

NEW ZEALAND

ROSE, JILL (p. 75)
 191 Miki Miki Road, RD 1, 5881 Masterton. **T** +64 6 3725992.
 E spellbound-binding@clear.net.nz
WILCZYNSKA, KAROL (p. 81)
 PO Box 1941, Shortland Street, 1140 Auckland. **T** +64 9 846 4188.
 E kwilczyn@aut.ac.nz

POLAND

TYLKOWSKI, JACEK (p. 78)
 ul. Blekitna 1/7, 60 656 Poznań. **T** +48 501190275.
 E info@introligatornia-tylkowski.com

RUSSIA

RUZAYKINA, MARIA (p. 75)
 Potapovskiy 10/42, 101000 Moscow. **T** +7 8 9165850328. **E** zoolyzoo@yandex.ru

SPAIN

BOSCH MALLEU, MAGDALENA (p. 54)
Costa de Saragossa 9, 07013 Palma de Mallorca. T +34 971 792 267.
E m.herbst@terra.es

GIL-DELGADO FRIGINAL, GONZAGA (p. 60)
C/Caracas 15, 7° izq, 28010 Madrid. T +34 617 566 482. E gdelgado@inia.es

GIMENEZ, EDUARDO (p. 11)
Paseo Constitucion, 29 Duplo, 7 Izda, 50001 Zaragoza. T +34 976 490149.
E egimenez@ya.com

PEREZ FERNANDEZ, MIGUEL (p. 42)
Rúa do Nabal 36, (Villestro), 15896 Santiago de Compostela. T +34 981 531 759.
E obradoiroretrincos_stgo@yahoo.es

SWEDEN

CARLSSON, KRISTOFFER (p. 26)
Leonard Gustafssons Bokbinderi, Artillerigatan 20, 114 51 Stockholm.
T +46 736456258. E fkcarlsson@gmail.com

HÜBNER, PER-ANDERS (p. 12)
Sven Jonsons Gata 2A, 30227 Halmstad. T +46 708133702. E pa@hubnerbokform.se

LANGWE, MONICA (p. 67)
Kulåravägen 23, 7920 90 Sollerön. T +46 250 222 16. E monica@langwe.se

LARSSON, ADAM (p. 67)
Gruvstigarvagen 1, 748 30 Osterbybruk. T +46 70 331 43 08.
E adam.larsson@ub.uu.se

SWITZERLAND

KREBS, STEFAN (p. 65)
PF 173, 2558 Aegerten. T +41 763834156. E s.krebs@mac.com

MEUTER, ROLAND (p. 38)
Höchistrasse 39, 6353 Weggis. T +41 41 390 02 63. E info@rmeuter.ch

VON ROTZ, HANS (p. 49)
Rosenweg 2, 6064 Kerns. T +41 41 660 52 78. E hans.vonrotz@ow.ch

WOLPER, FLORIAN (p. 81)
Junkerngasse 5, 5502 Hunzenschwil. T +41 62 544 25 12. E f.wolper@web.de

ZIMMERLICH, JAN PETER (p. 50)
23 rue de la Promenade, 2056 Dombresson. T +41 32 725 26 47. E info@livresses.ch

UNITED ARAB EMIRATES

LEIJONSTEDT, MIA (p. 36)
E leijonstedt@gmail.com

UNITED KINGDOM

ARROWSMITH, DAVID (p. 52)
32 Arthur Road, Edgbaston, Birmingham B15 2UN. T +44 121 440 6674.
E D.J.Arrowsmith@aston.ac.uk

BARTLEY, GLENN (p. 22)
14 High Street, Culham, Abingdon, Oxfordshire OX14 4NB. T +44 1235 526027.
E glenn.bartley@tesco.net

BROCKMAN, JAMES (p. 8)
High Ridge, Ladder Hill, Wheatley, Oxfordshire OX33 1HY. T +44 1865 875279.
E jamesrbrockman@aol.com

BROCKMAN, STUART (p. 23)

Willow Cottage, Steventon Hill, Steventon, Abingdon, Oxfordshire OX13 6AA.
T +44 1235 831320. E StuBrockman@aol.com

BROWN, ANDREW (p. 24)

5 Lord Street, Boughton, Chester, Cheshire CH3 5DL. T +44 1244 322975.
E abrown.lotus@fsmail.net

BROWN, HANNAH (p. 24)

Top Flat, 51 Woodstock Road, London N4 3ET. T +44 7740 082 672.
E hannah@han-made.net

BURTON, JOHN (p. 24)

Eastfield House, East Street, North Perrott, Somerset TA18 7SW. T +44 1460 75156.
E pa.burton@virgin.net

CAPON, LESTER (p. 25)

39 Barton Street, Tewkesbury, Gloucestershire GL20 5PR. T +44 1684 297728.
E lester@capon2.orangehome.co.uk

COCKRAM, MARK (p. 26)

Studio 5, The Mews, 46–52 Church Road, Barnes, London SW13 0DQ.
T +44 20 8563 2158. E studio5bookarts@aol.co.uk

COLE, CHERYL (p. 56)

CONWAY, STEPHEN (p. 27)

DAVIDSON, GEORGE (p. 57)

9 The Crescent, Eaton Socon, Cambridgeshire PE19 8HF. T +44 1480 213349.
E gddavidson@supanet.com

DELRUE, PAUL (p. 58)

Crispin, Mill Street, Ruthin, Denbighshire LL15 1HT. T +44 1824 707044.
E roz@rozhulse.com

DE VEER, MARYSA (p. 58)

42 Hare Hill, Addlestone, Surrey KT15 1DT. T +44 1932 845976.
E marysa@otterbookbinding.com

DUNN-COLEMAN, NICHOLAS (p. 28)

28 The Droveway, Hove BN3 6LE. T +44 1273 563318.
E keith.dunn-coleman@ntlworld.com

FRIEDRICH, ANNETTE (p. 10)

12 St Paul's Road, London N1 2QN. E ah_friedrich@web.de

FUNAZAKI, ERI (p. 30)

14 Chestnut Road, London SW20 8EB. T +49 20 8542 6478.
E erifunazaki@yahoo.com

GRETSCHMANN, TATJANA (p. 60)

56 Breakspears Road, London SE4 1UL. T +44 7766051369.
E tgretschmann@wowtele.com

GREY, JENNI (pp. 4–5)

26 St Luke's Road, Brighton, BN2 9ZD. T +44 1273 693139.
E jennigrey@btinternet.com

HAIGH, SIMON (p. 31)

56 Coniston Avenue, Headington, Oxford OX3 0AW. T +44 1865 437229.
E simon.haigh@ouls.ox.ac.uk

HARRISON, HEATHER (p. 32)

Victoria Cottage, 55 Green Lane, Formby, Liverpool L37 7BH.
T +44 1704 871569.

HICKS, CHRIS (p. 61)

Tor View, Cary Hill, Castle Cary, Somerset BA7 7HL. T +44 7743 539395.
E chrishicksbookbinder@btinternet.com

HOLLAND, KATE (p. 32)

 Court Farm, Court Lane, Corsley, Wiltshire BA12 7PA. **T** +44 1373 832712.
 E hollandswest@btinternet.com

HOOD, DEREK (p. 33)

 24 Junction Road, Bath, Avon BA2 3NH. **T** +44 1225 342793.
 E derek@derekhoodbookbinding.com

HOWELL, PETER (p. 63)

 27 Woods Road, Caversham, Reading RG4 6NA. **T** +44 1189 464495.
 E peterhowell@tinyworld.co.uk

ILLINGWORTH-COOK, DIANA (p. 33)

JAMES, ANGELA (p. 34)

 The Applegarth, Osmotherley, Northallerton, North Yorkshire DL6 3AF.
 T +44 1609 883224. **E** angelajamesbooks@aol.com

JARRETT-KERR, SARAH (p. 64)

 Yeo House, Nempnett Thrubwell, Blagdon, Bristol BS40 7UZ.
 T +44 1761 462 543. **E** sarah@jarrett-kerr.com

JOHANSSON, SOFIA (p. 64)

JONES, PETER (p. 34)

 80 Hartington Road, Brighton, East Sussex BN2 3PB. **T** +44 1273 674943.
 E peter.rjones@tiscali.co.uk

KIRKPATRICK, GEORGE (p. 13)

 54 St. Martin's Hill, Canterbury, Kent CT1 1PS. **T** +44 1227 765829.
 E thegeokir@yahoo.co.uk

KOCH, JEANETTE (p. 35)

 195 Victoria Park Road, London E9 7JN. **T** +44 20 8986 9235.
 E jeanettekoch@arnoreinfrank.de

KUNIKATA-COCKRAM, MIDORI (p. 36)

LAM, VERONICA (p. 66)

 28 Grand Avenue, London N10 3BB. **E** veronica.lam@schabas.net

MAKI, KAORI (p. 37)

 6 Glendene, 115 Victoria Drive, London SW19 6PR.
 E kaorijpcom@hotmail.com

MATSUNO, YUKO (p. 37)

McCOLL, MYLYN (p. 68)

 2 Fircroft Road, Chessington, Surrey KT9 1RW. **T** +44 20 8397 1349.
 E mmccoll@hotmail.co.uk

MITAMURA, NAOMI (p. 70)

 14 Spring Gardens, Chelsfield, Kent BR6 6HJ. **T** +44 1689 853670.
 E naomimitamura@yahoo.co.uk

NORWOOD, MARY (p. 16)

 Folly Lodge, Weavers Lane, Inkpen, Berkshire RG17 9DG. **T** +44 1488 669069.
 E mary@norwood.uk.com

PEACOCK, RICKY (p. 72)

 97 Halifax Road, Brierfield, Nelson, Lancashire BB9 5BY. **T** +44 1282 619214.
 E rickypeacock05@aol.com

RICHMOND, PAMELA (p. 74)

 9 The Green, Bishop's Norton, Gloucester GL2 9LP. **T** +44 1452 731051.
 E martin.griffiths@gloscol.ac.uk

RILEY, DOMINIC (p. 18)

 Low Wood House, Low Wood, Ulverston, Cumbria LA12 8LY.
 T +44 15395 31161. **E** rebound@onetel.com

SAUER, LORI (p. 75)

SELLARS, DAVID (p. 18)

19 Back Victoria Terrace, Eastwood, Todmorden, Lancashire OL14 6DJ.
T +44 1706 816997. E davidgsellars@yahoo.com

SHAW, CHRISTOPHER (p. 76)

1 Kennel Cottages, Cottisford, Brackley, Northants NN13 5SS.
T +44 1280 848818. E christopher_shaw@talk21.com

WARD-SALE, RACHEL (p. 49)

Star Brewery, Castle Ditch Lane, Lewes, East Sussex BN7 2DL.
T +44 1273 486718. E rachel@bookbindersoflewes.co.uk

YEVTUKH, ANNA (p. 81)

26 Charter Place, Worcester WR1 3BX. T +44 1905 619639.
E anna@annayevtukh.co.uk

UNITED STATES OF AMERICA

ADELMAN, CATHY (p. 52)

24764 W. Saddle Peak Road, Malibu, CA 90265. T +1 310 436 1794.
E c-adelman@msn.com

BARRIOS, PAMELA (p. 53)

BONAVENTURE, MARLYN (p. 23)

E marlynbonaventure@yahoo.com

CURRY, COLEEN (p. 56)

280 Pacific Way, Muir Beach, CA 944965. T +1 415 383 7385.
E curryc280@yahoo.com

FOX, GABRIELLE (p. 59)

PO Box 8877, Cincinnati, OH 45208. T +1 513 304 5758.
E gabrielle@gabriellefox.com

HANMER, KAREN (p. 61)

709 Rosedale Road, Glenview, IL 60025. T +1 847 724 6324.
E karen@karenhanmer.com

HOLTSCLAW, MONICA (p. 62)

520 Water Street, Celebration, FL 34747. T +1 206 291 5366.
E monicaholtsclaw@gmail.com

KAMPH, JAMIE (p. 64)

74 Wilson Road, Lambertville, NJ 08530. T +1 609 737 2130.
E jamiekamph@verizon.net

KELLAR, SCOTT (p. 35)

2650 W. Montrose Avenue, Suite 108, Chicago, IL 60618. T +1 773 478 2825.
E skkellar@sbcglobal.net

KIBBY, ESTHER (p. 65)

3017 Rosedale Avenue, Dallas, TX 75205. T +1 214 505 5524.
E ekibby@swbell.net

LALLIER, MONIQUE (p. 66)

7409 Somersby Drive, Summerfield, NC 27358. T +1 336 643 0934.
E folium@triad.rr.com

MARING, MARVEL (p. 68)

6131 Pacific Street, Omaha, NE 68106. T +1 402 884 8639.
E marvel.maring@gmail.com

MORROW, SANA (p. 70)

W www.sanamorrow.com

NELSEN, AMANDA (p. 40)

241 Hurley Street #3, Cambridge, MA 02141. T +1 617 864 2590.
E amandanelsen@hotmail.com

NITZBERG, NANCY (p. 70)
 7820 Spring Avenue, Elkins Park, PA 19027. **T** +1 215 635 4320.
 E NanNitzberg@aol.com
NOVE, JOHN (p. 71)
 42 North Main Street, Ipswich, MA 01938. **T** +1 978 356 0642.
 E john.nove@verizon.net
OWEN, PATRICIA (p. 41)
 3050 Airport Avenue #E, Santa Monica, CA 90405. **T** +1 310 398 5531.
 E owenjohnson@earthlink.net
PADGETT, MELINDA (p. 71)
 1515 Escalona Drive, Santa Cruz, CA 95060. **T** +1 831 427 9622.
 E mpadgett@ucsc.edu
PULLMAN, JANA (p. 74)
 3816 13th Avenue S., Minneapolis, MN 55407. **T** +1 612 822 7321.
 E pullmanjl@yahoo.com
REID-CUNNINGHAM, JAMES (p. 44)
 10 Harrington Road, Cambridge, MA 02140. **T** +1 617 354 4276.
 E james_reidcunningham@yahoo.com
SPITLER, PRISCILLA (p. 77)
 PO Box 747, Truth or Consequences, NM 87901. **T** +1 575 894 5701.
 E prispit@windstream.net
STACKPOLE, JULIE (p. 77)
 12 Gilchrest Street, Thomaston, ME 04861. **T** +1 207 354 6042.
 E elidor.stackpole@gmail.com
VANDERWERKER, GERRITT (p. 79)
 3076 Friendship Road, Waldoboro, ME 04572. **T** +1 207 832 7061.
 E bookbinder@gwi.net
VERHEYEN, PETER (p. 79)
 8 Pebble Hill Road North, Syracuse, NY 13214. **T** +1 315 443 9756.
 E verheyen@philobiblon.com